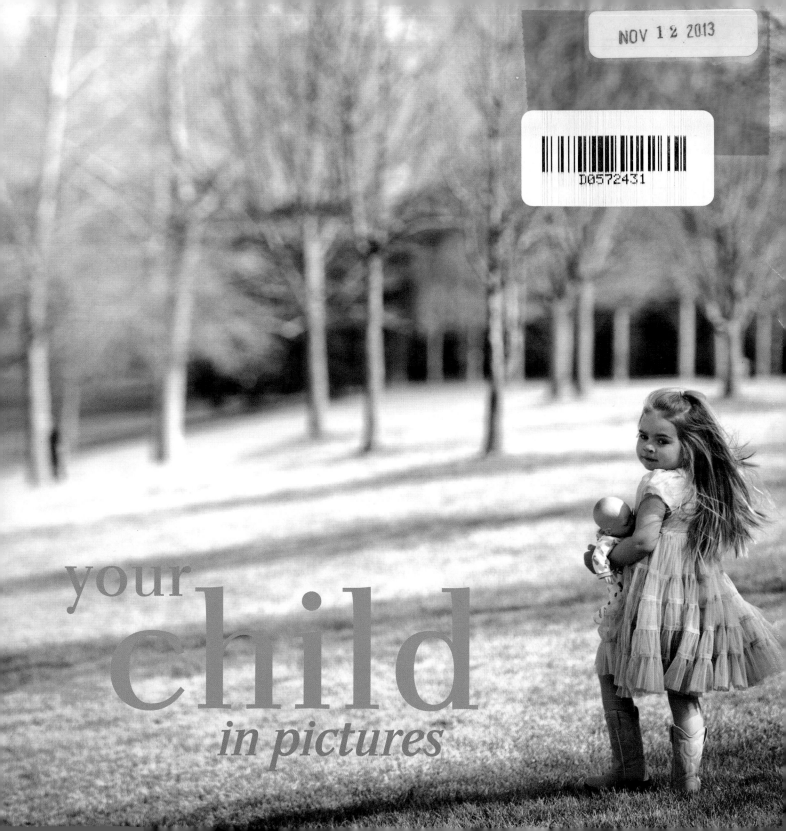

your
child
in pictures

AMPHOTO BOOKS

An Imprint of the Crown Publishing Group

New York

your
child
in pictures

ME RA KOH

THE PARENTS' GUIDE TO PHOTOGRAPHING
YOUR TODDLER AND CHILD FROM AGE ONE TO TEN

Published in the United States by Amphoto Books,
an imprint of the Crown Publishing Group, a division of Random House, Inc., New York
www.crownpublishing.com
www.amphotobooks.com

AMPHOTO BOOKS and the Amphoto Books logo are trademarks of Random House, Inc.

Library of Congress Cataloging-in-Publication Data

Koh, Me Ra
 Your child in pictures : the parents' guide to photographing your toddler
and child from age one to ten / Me Ra Koh.—First edition.
 pages cm
 Includes bibliographical references and index.
 1. Photography of children. 2. Portrait photography—Technique. I. Title.
 TR681.C5K645 2013
 779'.25--dc23
 2012028375

 ISBN 978-0-8230-8618-4
 eISBN 978-0-8230-8619-1

Printed in China

Design by Jane Archer/www.psbella.com

10 9 8 7 6 5 4 3 2 1

First Edition

For my mama

The simplest moment of childhood
became the most magical because
you slowed down and pointed out
the magic you saw in me.

acknowledgments

To all the readers of *Your Baby in Pictures* who made it their go-to baby-shower gift and asked for more, my heart is overwhelmed. To the contributing moms in these pages, your creative eye inspires us all. To the incredible families within these pages, it's an honor to capture your ever-evolving stories. To our team of certified CONFIDENCE teachers, thank you for carrying the vision of these pages to moms in your local communities. To the past workshop attendees, blog readers, and TV viewers who e-mail me stories, your enthusiasm for learning fuels my passion! To Julie Mazur, my senior editor at Amphoto Books, I love how you always see more books in me—your ever-increasing vision is an incredible gift. To editor Alison Hagge, I'm overwhelmed by your gift for bringing beautiful form and shape to these pages. To Nidhi Berry and Linda Kaplan of Crown's foreign rights department, thank you for championing the translation of this series to reach moms all over the world! To Stephanie Boozer, deep gratitude for the endless details you tied up and the immense joy you brought to this project. To Brian, my incredible husband, for how you hold me up, supporting me like no other, so that I can lock myself away to write. To my greatest treasures, Pascaline and Blaze, for the cards and little gifts you made me for every deadline I reached—I'm the most blessed mama in the world! Most of all, I give thanks to my Heavenly Father for restoring my voice so I might help others find theirs.

contents

preface: my story

Capturing the story of my children's lives has been one of the most rewarding honors of my life.

If you read *Your Baby in Pictures*, you will remember me sharing how I didn't find photography. Photography found me—and then it healed me. I bought my first SLR camera when I was turning thirty years old as an attempt to process the grief of miscarrying Aidan, our second baby. At the time, I was an author and speaking at women's events on the topic of recovering from sexual victimization. My first book, *Beauty Restored*, was based on my recovery and restoration after being date-raped. Photography was nowhere on the map for me, but with the painful loss of Aidan, my heart needed a new creative outlet—a way to process my grief. Little did I know that as I grieved Aidan's death, the birth of a new love would come.

I remember the afternoon it happened. Pascaline was eighteen months old and playing in front of the French doors. The afternoon light spilled into the room and illuminated her in such a magical way. I knew in that moment that even though I couldn't hold on to Aidan's life, Pascaline's life was here—right in front me—waiting to be captured, cherished. With my new camera in hand, she and I headed out to the garden. As a toddler, Pascaline was always intent on being my little helper. When she reached for the garden hose, instead of trying to keep her from becoming soaked, I stepped back and captured the moment with my camera. I went to the closest one-hour lab with my roll of film, and when I saw the results—her spirit and big eyes looking back at me—I was hooked.

Friends and family started noticing the photos and asked me to photograph their children. Before long, brides were contacting me to shoot their weddings. Within four years of buying my first SLR, I was shooting million-dollar weddings all over the country. My husband, Brian, joined me, and photography became a vehicle for us to work and grow in creativity together.

As much as I loved shooting high-end weddings, my heart has always been committed to empowering women, especially moms. This is what I spent my time dedicated to before photography, and I knew that this is what I wanted to get back to. A few years later, Brian and I made a decision to shift our photography business from being a boutique wedding business to empowering moms with a camera. Through my daily blog, I began to provide moms with photo tips on how to capture their children.

In a short period of time, my photography and photo tips were featured on *The Oprah Winfrey Show,* VH1, Lifetime television, as well as in the *New York Times* and on exhibit in New York City. Yet I still wanted to reach more moms, to inspire their creative spirits. It was time to return to speaking engagements, and in the process, my passion for empowering women grew a thousand times stronger.

In 2009, the *Nate Berkus Show* on NBC invited me to be its guest photo expert for two years to inspire its millions of daily viewers. Sony invited me to be its first female sponsored wedding and portrait photographer. Brian and I wrote the award-winning instructional DVDs *Refuse to*

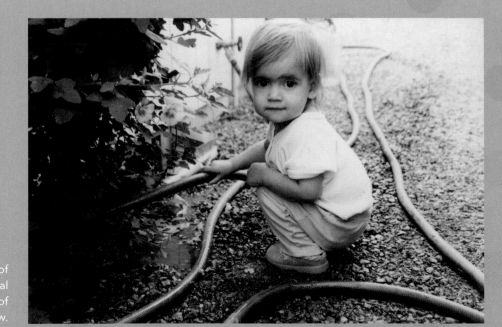

Capturing the everyday moments of Pascaline was a way for me to heal and cherish the simple beauty of her life—right here, right now.

Say Cheese and *Beyond the Green Box* for moms who want to learn how to capture their kids. We also continued teaching—for more than five years we have sold out our CONFIDENCE photography workshops to an audience of women nationwide. We now have a team of certified women to teach our CONFIDENCE Workshops to their own local communities—growing confidence in one mom at a time. And in 2012, Disney approached us with an opportunity to host my own show, *Capture the Story with Me Ra Koh*. But the best part of all is that during this time, we were blessed with the birth of Blaze, our baby boy.

All of these honors and gifts have been amazing, because I never imagined I'd be a photographer. I didn't go to photography school, and in fact, I did horribly in school, struggling with several learning disabilities to only get a C+, if that. On top of feeling inferior at school, I had a painful childhood. Nothing has ever come easily for me, and photography is no exception. But sometimes, when life pushes us so hard, we surprise ourselves and push back just as hard, achieving more than we ever expected.

I remember feeling lost when I tried to read my camera manual. When I visited the local camera shop for guidance, the man behind the counter made me feel even more inferior, and yet I was determined to find a way, because capturing my children in pictures was (and is) that important to me. So I created explanations that made sense to me. And, after meeting thousands of women during the last ten years, I know that I'm not the only one who sees things this way. That is why I wrote the first book in this series, *Your Baby in Pictures*. The tremendous

As women, we battle so many voices that tell us we aren't good enough, creative enough, even worthy enough. One of my greatest joys is to speak to the hearts of women, empowering them in their creativity and confidence, as at this keynote address to an audience of twelve hundred women. Photo by Joy Neville.

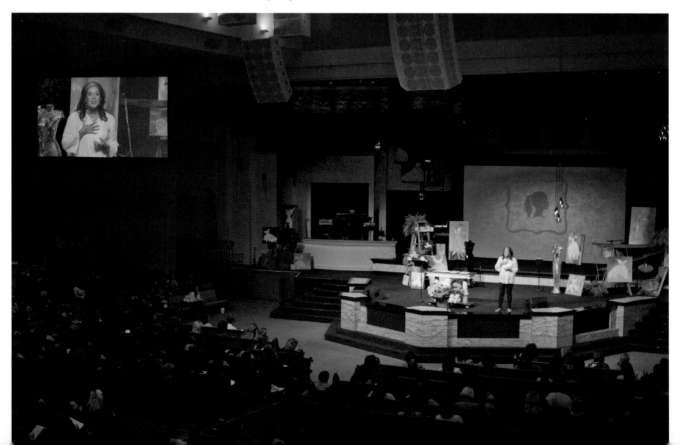

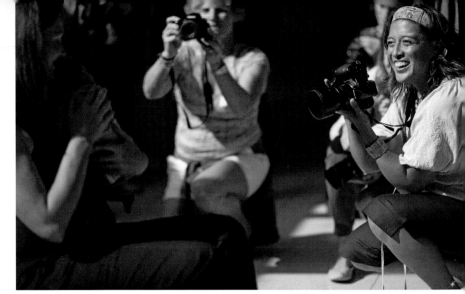

At our CONFIDENCE Workshops, women find that their eye for the world around them is not only beautiful but incredibly powerful.

response to this book, from real moms trying to figure out how to capture their babies, got me thinking about the next stage in parenting. *Your Child in Pictures* is the result.

As with the first book, you will read many "Me Ra–style" explanations intended to demystify the technical side of photography, along with all the camera settings I used to create the images you see here. If you are like me, you want to know the camera settings for every photo until you feel comfortable creating your own. My intent for this book series is not to wow you with my abilities. Rather, these books are about empowering you to capture your child's life, regardless of what type of camera you have. In this second book, I'm honored to share not only my photos but photos from other moms who have come to our workshops (some of whom have gone on to become our certified teachers), watched our DVDs, seen my photo tips on TV, or followed along in my daily blog. As you will see, each of us has our own unique eye for capturing the unfolding story of our children's lives. Each of us has inspiration to share.

A creative process works itself out through stages; some stages come easily, and some are just plain tough. Photography is the same. Some stages involve a lot of hard work and commitment to simply not give up, like capturing a busy toddler who may run away every time you pull out the camera. Other stages feel easy and delightful, like collaborating with your seven-year-old on a photo that captures her current hobbies or loves. Regardless of what stage your child is in, the end result is worth it all. Your children watch you develop a passion that feeds your creative spirit. They, in turn, start to develop their own creative voice. What once started as a simple hobby is now enriching the family on multiple levels.

Imagine the fun you will have when your child is grown and you have a collection of stories—not simply photos, but rich, visual stories—to share that chronicle his growth as well as your own creative growth. Talk about inspiring! And to think it all began with your determination not to be intimidated or to feel afraid that you weren't creative enough to capture beautiful photos. If I can pick up a camera and teach myself how to capture my children, you can, too. Prepare to find hundreds of photo secrets I have learned along the way as well as easy explanations, written from one parent to another. You can do this! It's not about whether you have a fancy or cheap camera; it's about your passion to capture the fleeting stories that evolve in your child's life with each new stage of childhood.

Roll up your sleeves, and let's dive in. We've got stories to capture!

Much love,
Me Ra

> **The soul is healed by being with children.**
> —EMMA GOLDMAN, *Mother Earth*, APRIL 1913

introduction: capturing the magic of childhood

eing a parent in today's world is not for the faint of heart. Many of us manage the demands of parenting while at the same time working demanding jobs. Being pulled in several directions at once, we look for ways to savor every moment with our children. But somehow time moves too quickly. We find ourselves wishing we could make time stand still and hold on to the days when our little ones held our hands on walks or ran into our arms when they fell down.

As a mother and then a professional photographer, the camera has been my vehicle for slowing down, taking in the beauty of the moment at hand, and savoring the magic of childhood in my own kids as well as those of my clients. But for many of you, this may not yet be the case. There are so many incredible moments to capture in a child's life, it can be difficult to know what to focus on. Instead, you may find yourself trying to capture *it all*. The result? Three hundred photos of your child's third birthday but not one print hanging on the wall. My sense is that many of us have a deep desire to slow down, exhale, and take in one moment—the single story of an unfolding, developmental milestone that documents our child's life.

Your Child in Pictures will help you do just that. A response to so many of you who enjoyed my first book, *Your Baby in Pictures*, this second book continues the journey, pointing out key developmental moments so you, too, can slow down and capture the incredible, evolving change that is happening in your child.

As your children grow, so also must your approach to photographing them. This is why I've broken up this book by age-group: one to two years, three to four years, five to seven years, and eight to ten years. Each chapter features five quick tips for photographing that age-group and then ten photo "recipes" to try with your child. Get ready to learn not only the ingredients for taking each picture but all the secrets and steps behind the photos, too.

Each photo recipe walks you through the following:

- When to take it
- How to prep for the shot
- What settings to use for a point-and-shoot or DSLR camera
- Composition and framing tips
- Where to focus before shooting
- And everyone's favorite, the exact DSLR settings used for the photo shown, including the aperture, shutter speed, and ISO. In fact, you'll start to discover the consistency within the camera settings I use so that you can branch off into your own experimentation. You may only have a point-and-shoot or

camera phone now, but this book will grow with you when you are ready to upgrade to a DSLR.

All forty photo recipes can be followed with either a point-and-shoot or a DSLR camera. However, point-and-shoots can be incredibly limiting, and if you are sitting on the fence about upgrading to a DSLR, I encourage you to read chapter 1 to help you make your purchase decision.

Tucked within the pages of this book, you will find inspiring moments captured by moms, just like you, who have attended my CONFIDENCE Workshop, watched my instructional DVDs, or followed the photo tips on my blog. Each of us sees the world in a unique way, and I am honored to let their images enrich this book for you that much more. The goal is not to shoot photos that look like mine but to find joy in discovering your own eye.

In the appendix, you will also find tips on how to capture a child with special needs. Over the years I have met many parents who feel uncomfortable hiring a photographer for fear that their child will not be understood or appreciated. These resilient, dynamic children must be approached in a different way from many of their peers. With the help of moms who know this field intimately, I am excited to empower and encourage you in capturing the story of your beautiful child.

For those who demand perfection of yourselves from the get-go, I must tell you: photography takes practice. The goal of this book is not to capture perfection but the beauty of your child's everyday life. So take a break from the never-ending demands of home and work, and come with me to a quiet place where you can exhale. The reward is twofold. You will become empowered with tricks and techniques to chronicle your child's life, while at the same time growing in your own creativity. In return for your dedication, photography will become an exciting vehicle for you and your child to experience together. Enjoy!

gearing up

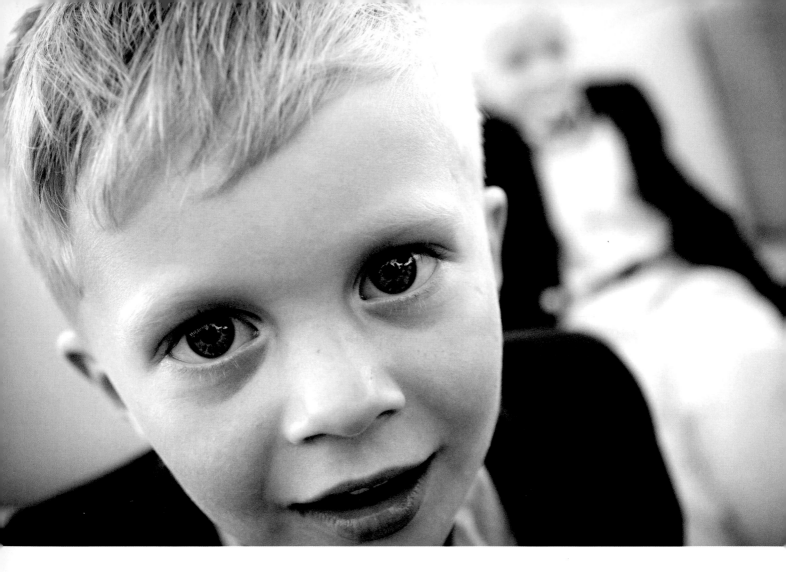

have you ever stood at the counter of a camera store and felt overwhelmed? Or maybe you've gone online to look at camera options and felt cross-eyed when confronted with features that sounded like a foreign language? You know you want a fast camera to capture your little one in motion, but what else do you need? What equipment is necessary, and what is just "noise"? In this chapter, I'll discuss everything from what camera to consider to tips for maximizing the camera in your smartphone. And since readers of *Your Baby in Pictures* loved the tips on finding great light and improving your photos overnight, I'm back with even more!

choosing a camera

It is amazing how technology continues to evolve. Even since the publication of *Your Baby in Pictures*, the market has seen a host of new camera features. Some are game-changers in the industry; others are what I call "bells and whistles" that are not necessary. If you already have a camera that you are happy with, you may just want to skim this section for future purchases. But if you are looking to buy a camera, the type you choose is a big decision that will impact your photography for years to come. Let's look at some key benefits to point-and-shoots (P&Ss) versus DSLRs and the all-new hybrids.

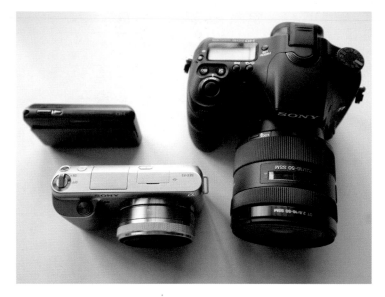

Consider the pros and cons of different camera models before making a purchase. Shown here are (clockwise from top left) a point-and-shoot, a DSLR, and a hybrid.

THINGS TO CONSIDER WHEN BUYING A POINT-AND-SHOOT

Point-and-shoots often get a bad rap, because they aren't "real" cameras. However, in today's market, point-and-shoots are better than ever. How do you know which one to choose? Look over the tips below to find the model that will best fit your needs. Keep in mind that even though point-and-shoots have become much more advanced, many still hit a glass ceiling when it comes to their ability to control exposure, create soft-focus backgrounds, and, most of all, have enough speed to capture the moment. You may want to consider the new hybrid cameras discussed below. But if a point-and-shoot is what your pocketbook can afford, look for these features to help you choose the best one.

PRINT SIZE AND MEGAPIXELS. Megapixels are directly connected to how big your prints can be without losing quality. If you will want mainly 4 x 6–inch or 8 x 10–inch prints, 5 megapixels is enough. For 11 x 14–inch prints, get a camera with 8 megapixels. For 16 x 20–inch prints, 15 megapixels is best. If you share most of your images digitally (sending in e-mails, posting on Facebook, and so on), then between 5 and 8 megapixels is plenty.

OPTICAL VS. DIGITAL ZOOM. Most point-and-shoots do not allow you to switch lenses, so you'll want the ability to zoom in for close-ups and zoom out for wider shots. Look specifically for optical zoom rather than digital zoom, which leads to lower-quality images.

DURABILITY. There are a number of weatherproof, water-resistant, and/or waterproof point-and-shoots on the market. Many are supposedly even able to withstand being dropped. Since we are talking about taking pictures of kids, it may be worth investing a few more dollars in one of these models if you know you are going to be poolside or at the beach (not to mention how those little hands can grab expensive things and drop them).

FAST/CONTINUOUS SHOOTING MODE. Make sure you have the option of choosing Fast or Continuous Shooting mode so that you can take multiple images per second. This may also be referred to as FPS (frames per second) by the camera manufacturer.

SCREEN RESOLUTION. The little screen on the back of your point-and-shoot is a big deal, because it is what you look at to take a photo. Make sure your screen display is at least 2½ to 3 inches in size. This will be easier on the eyes and increase your odds of successful picture-taking.

HDMI OUTPUT. If you want to view your images on a television screen, it's wonderful to have an HDMI output, so you can plug the camera straight into your TV.

HD VIDEO. If video is at the top of your list, look for full high-definition 1080/60p to get the highest video resolution with the smoothest playback image.

When you are at the camera store, ask the salesperson if you can step outside to take a few test shots with different models. Ask a friend (or willing subject) to stand in the same place for every photo, and take a few shots with each camera to see which captures the best skin tones. (This exercise won't work as well inside the store because of the fluorescent lighting.)

Children, especially little ones, move fast! Make sure your point-and-shoot offers Fast/Rapid/Continuous Shooting mode so that your camera fires at a decent pace. This won't match the speed a DSLR provides, but you will still catch the sweet variations that happen within a few minutes.

THINGS TO CONSIDER WHEN BUYING A DSLR

Owning your own DSLR opens you up to a world that a point-and-shoot can't reveal. As your comfort with your DSLR grows, you will have the opportunity to control all the settings! But (and this is a big but), if you don't understand how to get off Auto mode (what I refer to as going "Beyond the Green Box"), your DSLR can end up taking photos that look, well, just like those you took with a point-and-shoot. To avoid this expensive frustration, consider the tips on page 22 as well as in the photo recipes throughout the book.

TRANSLUCENT MIRROR TECHNOLOGY. Gone are the days of guessing whether different settings will make your image brighter or darker. The "Live View" LCD display on the back of your camera—as you speed up or slow down your shutter speed, or change the ISO—allows you to watch the Live View become darker or brighter. Traditional DSLR cameras shoot more slowly when using this LCD Live View feature (versus looking through your viewfinder), but translucent mirror technology fixes this, giving you the same speed you'd get if looking through your viewfinder. This way, you can hold the camera down to shoot at eye level with your kids and avoid covering your face with the camera—all without missing any of the action shots!

IMAGE STABILIZATION. When taking pictures of kids indoors, we often end up with blurred motion. This is because there wasn't enough light and either our hand moved or the subject moved. One solution? Image stabilization. This feature uses motion sensors to make adjustments for low light so that you get as little motion blur as possible. Look for camera models that have image stabilization built into the camera body, so you have it for every shot, versus having to buy special Image Stabilization lenses.

ISO PERFORMANCE. The ISO is the sensitivity of a camera's sensor to light. Entry-level DSLRs (typically those under a thousand dollars) have an ISO "ceiling" of 800, beyond which images tend to show noise, or grain, which dilutes image quality. I've met countless moms who are frustrated, because every time they take pictures at home, they have to be at ISO 800 due to low lighting. If you, too, will be shooting a lot at home, the more expensive DSLRs with higher ISO ranges will make a huge difference. Some DSLRs boast ISOs of up to 128,000!

USER-FRIENDLY MENU. As you examine various brands, ask yourself whether the menu is intuitive and easy to navigate. Or do you find yourself fumbling around, unable to locate the settings you need? Having the ability to react quickly will make all the difference when you need to change your settings before the special moment is gone.

WEIGHT AND SIZE. If possible, handle the DSLR you are considering. Does it feel heavy or too light? Does the size of the camera fit well with the size of your hands? Eventually, you will want your DSLR to feel like an extension of your body.

SAY "NO, THANK YOU" TO THE KIT LENS

If possible, buy the camera body and pass on the kit lens that comes with it. The kit lens isn't worth much and will make you wonder why you upgraded from your point-and-shoot. In fact, the lens is so important that if you have to choose between buying a nicer camera body or a separate lens, invest in the lens.

My two workhorse lenses are the 24–70mm F2.8 and the 70–200mm F2.8. Both give me the option to have a buttery, blurry background, but one is for taking portrait-like photos, and the other is for when I'm on the sidelines at one of my kids' sporting events.

THE NEW HYBRID CAMERAS

If you've ever dreamed of having the technology of a DSLR in a camera the size of your point-and-shoot, you are in luck! Here are a few star features that are making photographers fall in love with hybrids, also known as "compact interchangeable lens cameras."

INTERCHANGEABLE LENSES. Unlike a point-and-shoot's built-in lens, hybrids allow you to change lenses.

SMALL SIZE, GREAT PERFORMANCE. Hybrids are as small as point-and-shoots, but the sensors are as big as those in many DSLRs, for beautiful detail and enlargement quality.

SPEED. Hybrids are fast, in terms of both autofocus speed and the number of photos you can shoot per second (FPS—frames per second).

HD VIDEO. Hybrids offer amazing high-resolution video.

Hybrid models, also called compact interchangeable lens cameras, capture quality like a DSLR but fit in your purse like a point-and-shoot. They're the best of both worlds!

HELPFUL CAMERA ACCESSORIES

These five different camera accessories range in price from free to a few hundred dollars, but all of them will make your picture-taking easier, get your creative juices flowing, and add a little extra joy (and style) to your photographic journey.

LENS HOOD. Some of you may be shocked to hear this, but I never use filters on my lenses—not even a UV filter. Why would I spend $1,500 on a lens only to cover that beautiful glass with a $100 filter made of plastic? You may say, "To protect the glass on that $1,500 lens"—but that is what my lens hood is for. A lens hood blocks direct light, so you won't get sun flare, and also offers protection against scratching your lens glass. My lens hood is always on when I'm shooting, whether I'm outside or inside.

If your images often look foggy or hazy, try attaching a lens hood to help block directional light.

BIG MEMORY CARD. Cards today have become huge and fast! I love putting a 32G card into my camera and never having to pause during a photo shoot to change cards. The only drawback is that you may be tempted to overshoot. Always be conscious of not overshooting just because you have the room to take endless photos.

CARBON-FIBER TRIPOD OR GORILLAPOD. With the bendable legs and versatility of these tripods, you can clamp your camera to railings, branches, window shutters, the headboard of your bed—you name it! There isn't a space that your camera can't go.

EXTERNAL HARD DRIVE. If you're like me, you are eventually going to take so many photos that your computer will run out of space. Or worse, your computer's hard drive will crash and you will lose all your images. Don't risk it! Buy an external hard drive, whether to keep a backup copy of your images or simply keep your originals off your computer's hard drive. For under a hundred dollars, you can buy a "mini drive" (for example, to take on vacation) or invest in a terabyte-sized external drive that will hold thousands of images. I keep three backups of everything I shoot, knowing that hard drives and external drives are susceptible to crashing.

CUTE CAMERA BAG. Back in the day, the only camera bags on the market were black and serious looking. I used to wrap my expensive camera in a scarf, bubble wrap, even a *diaper* so that I could still use my purse and avoid a boring camera bag. Times have changed! If you are open to investing a few extra dollars, you can have a camera bag that is not only functional but something you are proud to carry. I can't tell you how many times women have asked where I bought my purse, only to be shocked that it's a camera bag!

easy camera settings for taking better photos

Many of us don't realize that camera manufacturers often set cameras to default settings. We pull the camera out of the box and expect to start shooting what we see, but the camera settings aren't set up in our favor. In *Your Baby in Pictures*, I listed a handful of settings that you can easily change to transform your photos overnight. Here are a few of them again, along with some new ones!

1. TURN OFF THE BEEP. Many cameras emit a little beep when you focus on your subject. It doesn't seem loud, but it's loud enough for kids to hear. When capturing the stories of our kids, we want to avoid anything that will disrupt their present moment of play. Turning the beep off is a simple trick that makes a *big* difference.

2. TURN OFF THE FLASH. Turn off the flash, and use natural light from a window or other source whenever possible (see 5 "More" Tips for Finding Great Light, page 25). If light is dim, try raising your ISO. This allows you to shoot in low light without a flash. Just keep in mind that the higher your ISO, the grainier your image (depending on the quality of your camera). The lower the ISO, the less grain and the better your color saturation.

3. IF YOU HAVE A POINT-AND-SHOOT, USE PORTRAIT MODE. If you love the blurred background look (as on page 45, for example), use Portrait mode, indicated by a little face icon. This is a fully automatic mode that gives you more of a buttery, blurry background. The degree of blur lets people know what the story's focus is (and isn't). You'll see me use this effect over and over throughout the book. Just be aware that you'll hit a glass ceiling when it comes to blurring with a point-and-shoot. Many people invest in DSLRs just so they can get more dramatic results.

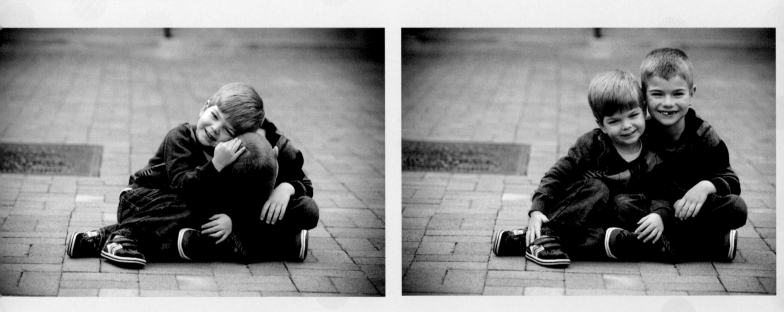

One of the main reasons people invest in a DSLR is for speed. Continuous Shooting mode on a DSLR allows you to capture multiple frames per second. And no one wants to miss one rascally second of brothers being brothers!

4. IF YOU HAVE A DSLR, USE APERTURE PRIORITY MODE.

For buttery, blurry backgrounds with a DSLR, use Aperture Priority mode. This lets you focus solely on your f-stop—the setting that determines depth of field and how blurry your background will be—while the camera automatically selects the appropriate shutter speed.

5. CONTINUOUS SHOOTING MODE.

Most cameras have a Continuous Shooting mode that allows you to capture multiple images in a few seconds simply by keeping the shutter button pressed down. Some manufacturers call this mode Burst or Multiple Frames. This mode allows you to catch those great facial expressions or action moments. You can also take one image at a time while using this mode, but if your finger gets a little heavy, the camera will start shooting frame after frame. I often keep my point-and-shoot and DSLRs on Continuous Shooting mode so that I am always ready for unexpected facial expressions or action.

6. ADOBERGB FOR BEST COLOR.

To get the best color quality in your prints, go into your camera's menu and choose Color Space. Your camera is most likely set for sRGB, and you want to change it to AdobeRGB. This will give you the most diverse color spectrum. If you don't have AdobeRGB as an option, your next best choice is sRGB.

7. SPOT METERING MODE.

If you want to experiment with shooting in Manual mode, take your metering mode off default and set your camera to Spot Metering mode. This tells your camera to only measure the amount of light in the center of your frame (instead of throughout the frame) and lends to more dramatic lighting. See the photo recipe chapters for ideas on how to take advantage of Spot Metering.

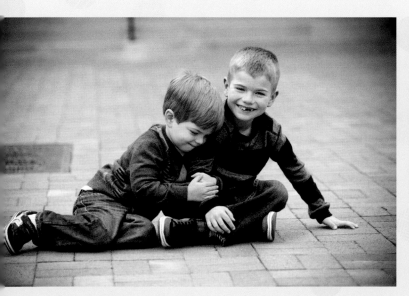

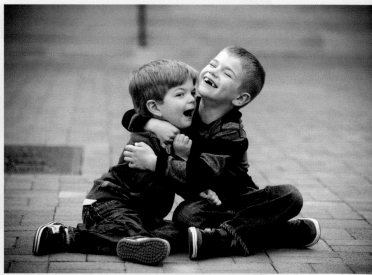

10 ways to maximize your smartphone camera

Pro photographer Chase Jarvis says, "The best camera is the one that is with you." He was referring to smartphones, and he couldn't be more right. Here are some easy tips to take the best photos possible with your phone.

1. SKIP THE ZOOM AND GET CLOSER. Camera phones are limited to digital zoom only, which compromises resolution to "zoom in." Instead, simply walk closer to your subject to avoid losing image quality.

2. SET RESOLUTION TO HIGH. Some camera phones have adjustable quality settings. Make sure you always use the highest resolution.

3. PLAY WITH THE TONAL RANGE. Turn on the HDR mode. This mode will take three exposures (pictures) and produce a blended final image to help you get good highlights, shadows, and midtones so that detail isn't sacrificed.

4. WATCH THE LIGHT. Many camera phones aren't as sensitive as point-and-shoots, and quickly lose detail, definition, and noise control when things get dark, so always pay close attention to the light. That said, play around at dusk and nightfall for more golden light; the results can be rewarding.

5. USE RAPID FIRE. Some camera phones include a "rapid file" feature, which allows you to take tons of photos in quick succession by keeping the shutter button depressed; others require a downloadable app to do this. Either way, keep pressing the shutter button as you walk around your subject, get closer, or change angles. You don't want to miss a moment. You can delete the outtakes later.

6. BE SNEAKY! Kids are well-accustomed to seeing us with a phone in hand. Take advantage of the phone's low profile and be sneaky by blending in and catching unexpected candids. Be the silent observer your kids don't even notice.

Camera phones can capture unexpected moments without making a sound. Take advantage of this unassuming camera device, like when you come to a red light and turn around to find your child asleep in the backseat of the car.

7. GET MOBILE. The beauty of camera phones is their simplicity and ease. Explore unusual angles and vantage points to see how they affect your image.

8. CLEAN THE GLASS. Since camera phones are constantly in our and our child's hands, don't forget to wipe the lens often. This is a high-traffic area for finger smudges.

9. PAUSE AND CHECK THE BACKGROUND. Take a moment to make sure the background is not cluttered or chaotic; otherwise, you may lose focus in your image.

10. PLAY WITH APPS. Play around with the many photo apps available, and don't be afraid to experiment with different effects. One of my favorite apps is Instagram, which allows you to take a normal photo and make it look extraordinary by applying various filters.

5 "more" tips for finding great light

You don't have to attend photography school to learn how to find great light; you simply have to train your brain to look for it. Like detectives, photographers are always searching for the best light and taking mental notes: Is the light harsh or soft? What direction is it coming from? What color is the light? These are questions that can all be answered before a single picture is taken. Here are five more tips to add to the ones in *Your Baby in Pictures* for finding great light.

1. OPT FOR THE PARKING LOT VERSUS THE PARK. We may think the park is the perfect setting for photos, but have you ever noticed how much light the grass sucks up? Grass can absorb light and reflect color, sometimes lending a green hue to your child's face. But if you are standing on cement, like a parking lot, sidewalk, or even your driveway, the light hits the cement and reflects a flattering light that fills all shadows!

Think twice when taking photos at the park. As in the first photo (left), grass absorbs light, making the image darker, and even creates shadows on faces. Concrete (such as sidewalks and driveways) bounces a more flattering light onto your child's face, often filling shadows that can show up in the grass (right).

2. LOOK FOR THE BOUNCE. Photographers understand that light is always bouncing from one surface to another. The trick is to position your subject's face to capture a soft bounce of light. Look for a building with a large, white exterior, and have your subject face the wall. Slowly have your subject shift with you, eventually making a full circle. As your subject shifts and begins to look away from the white wall, notice how you begin to lose light on her face. When her back is to the wall, is her face darker? Decide which degree of bounce you like best.

3. HOLD UP YOUR HAND. Whether you are indoors or outdoors, hold up your fist and turn it different angles to see how the varying light affects the color of your skin and the depth of shadows. Knowing where the best light is coming from will help you position your subject.

4. HARSH SUN? PUT THE SUN BEHIND YOUR CHILD. If the sun is too harsh, turn off your flash, and instead of having your children face the sun (and squint), have them stand with the sun behind them. This can sometimes create a nice halo or rim-light effect.

5. DO A WALK-THROUGH. Become intimately aware of when and where the best light shows up in your home. Walk through your house and notice which rooms are brighter than others. Do this several times throughout the day, even taking pictures of each room to see how the light changes. Notice how dramatic the light is at sunrise and sunset. Which rooms are brighter, and when are they at their peak of sun? Are some rooms too bright? A sheer curtain can be used to soften harsh light, acting as a perfect diffuser.

When the sun is harsh, turn off your flash, and keep the sun behind your kids to avoid squinty eyes and instead capture a beautiful halo, or rim-light, effect.

10 quick tips for getting great shots

These simple, no-nonsense tips were inspired by the questions I'm most frequently asked. Great photography isn't about how technical you are but about how willing you are to risk and risk again—all the while learning from your mistakes. Play with these tips, allow yourself to make mistakes, and watch your photos change overnight!

1. TURN YOUR FLASH OFF. The built-in auto flash often fires when you don't need it, diluting skin tones and color and creating harsh shadows. Instead of firing your flash, position yourself next to good window light or raise your ISO.

2. PREVENT RED-EYE. If you can't escape using your flash because it's simply to dark, take advantage of your camera's Red-Eye Flash mode. There are also a number of software programs that can fix red-eye after you take the photo, but the less time I need to spend on the computer fixing photos, the better.

3. GET CLOSER. Before taking any shot, pause and ask yourself if there is unnecessary background in the frame. If yes, get in closer. When our children are constantly on the move, it's easy to become fixated on just getting the shot. But there is nothing worse than having a large background that swallows your child or a soda can that you could have moved. How little can you leave in the photo while still telling a story? Challenge yourself with the motto "Less is more."

When you get closer to fill the frame, you accentuate your subjects' emotion and facial expressions that much more.

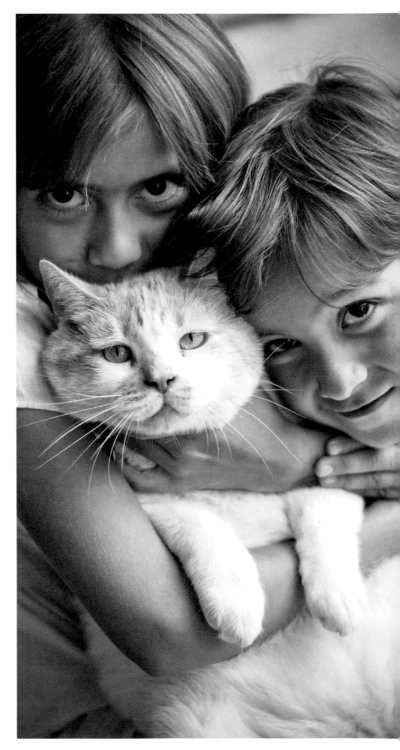

4. TUCK YOUR ELBOWS AND ANCHOR IN. If you move the camera while taking a photo, especially in low light, you'll end up with motion blur. To avoid this, tuck in your elbows so that your body is a solid entity, and then lean against a wall or rest your arms against a solid object (like a table) to decrease any movement on your part. Notice how your elbow pops up when you are shooting vertical frames? To avoid this, I use a vertical grip on my camera body, so both of my elbows stay tucked in whether I'm shooting horizontal or vertical frames.

5. GET DOWN TO THEIR LEVEL. When photographing kids, get down to their level, whether you sit on the floor and shoot straight on, lie on the ground, or use Live View to sneakily hold the camera at knee level. Alternatively, try standing on a chair and shooting down on your little ones as they look up at you, to show off how small they are.

6. PREPARE SPECIFIC STRATEGIES. Don't be discouraged if your child challenges you with the camera. In fact, prepare strategies for the specific temperament of your child. If your child is high-energy, ramp up the energy versus trying to calm him down. Maybe have Dad hold him tight and tickle him! If you have a toddler, be prepared to distract her over and over again, just as you can expect toddlers to become distracted on their own. The trick is to keep their attention coming toward you. Look to the photo recipe chapters for strategies on how to capture specific age-groups.

7. LET LOOSE. Older children can become self-conscious when a camera is pointing at them. One of the best ways to combat this is to let loose yourself. Get silly. Shake that stiffness out of your own body, and invite them to do the same. Being willing to look foolish, make funny sounds, even bark like a dog will make all the difference in having natural smiles and giggles versus stiff statue poses.

8. FIND AVAILABLE LIGHT BY TURNING OFF THE INDOOR LIGHTS. This is counterintuitive because we are often trying to figure out how to "add" light to a room, but sometimes we need to turn off the indoor lights to see the dramatic window light.

9. TAKE THE CAMERA OFF DEFAULT SETTINGS. Spend a few minutes changing your camera's settings (see page 22). A few quick adjustments will make all the difference. As you play with the photo recipes in the upcoming pages, give yourself the freedom to get off the auto or default settings.

10. SHOOT IN MORNING OR AFTERNOON LIGHT. That magical, golden light that we drool over in photos only happens twice a day: sunrise and sunset. I plan my shoots around the two to three hours leading up to sunset. If possible, avoid shooting at noon, when the sun is directly overhead and casts Dracula-type shadows under the eyes. If you must shoot at noon, find open shade in the shadow of a building or under some trees.

DSLR USERS:
SHUTTER SPEED DISPLAY

Within the DSLR settings, you will notice that I include two versions for the shutter speeds: one a fraction, the other a whole number (i.e., 1/60 sec. or 60). I do this because some cameras show you shutter speed as a fraction, others as a whole number, and this can really confuse people. The two numbers mean the same thing: 1/60 of a second. Check your camera to see how it displays the shutter speed.

Not every photo you take will be perfect. Often the most unexpected shot, even the blurry ones, will tell the story most powerfully.

BE WILLING TO MISS SHOTS TO GET GREAT SHOTS

The technology in today's digital cameras can make you feel like you should be able to capture every moment. I've watched this misconception overwhelm parents. They frantically try to capture it all, but five hundred photos later, they don't know what the story is about or how to pick one print for the wall. The truth is, we can't possibly capture every great moment we see our children experience. And if we start to think we can, we will quickly lose the joy we first felt when we started taking our child's picture. My firm belief is that we have to be willing to miss shots to get great shots. Slow down, look for the story you want to tell before you even lift the camera to your eye, and focus on capturing one moment, rather than every moment!

REFUSE TO SAY CHEESE®:

capture *the* story

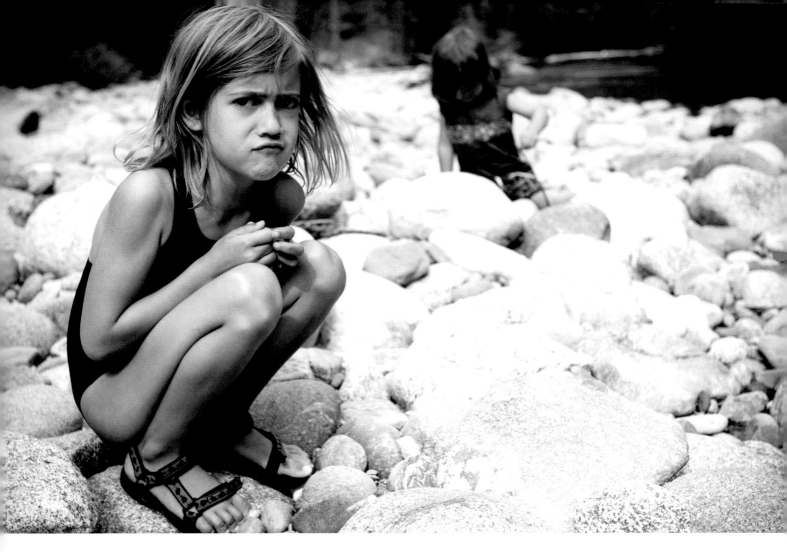

When Blaze was born, Pascaline was never shy about her feelings on the matter. If Blaze cried, she'd suggest he sleep in the garage. Thank goodness this was only a phase, but in the meantime, the neighbor's cat, Bob, kept her company. Every afternoon, Bob and Pascaline would lie in the grass while she poured out the troubles of being a big sister. It was a story I had to capture! I didn't want Pascaline to hear me, for fear of her turning around and the moment being gone, so from a distance, I zoomed in and captured the two friends. Imagine how different the photo would be if I had said, "Pascaline! Can you turn around and say 'cheese'?" The story would have been lost. Now, years later, I can look at this photo and be right back in the story of her once-troubled heart.

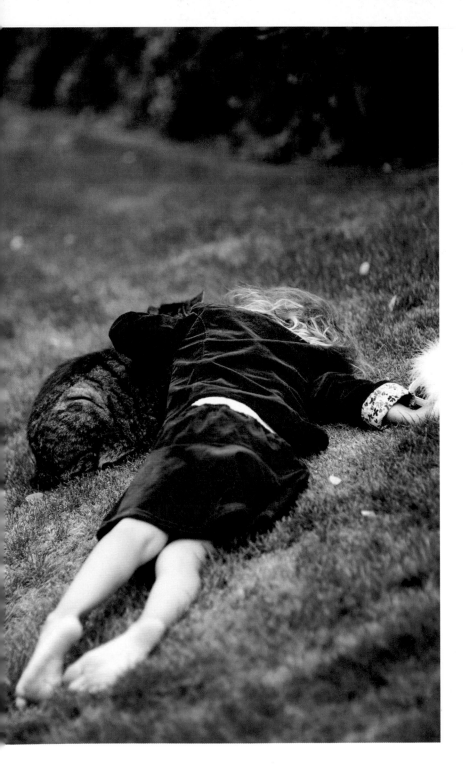

REFUSE TO SAY CHEESE

We've all experienced the same scene. Our kids are playing, looking so cute, so we pull out the camera and ask our kids to say "cheese." All of a sudden, our kids leave their play world and smile for the camera. There is nothing wrong with capturing those sweet smiles. We absolutely want to capture their smiles! But if the smile is the only thing we capture, we have missed out on the rich stories of their ever-changing lives.

When we ask our kids to say "cheese," we are essentially asking them to perform for us, sending the message "Your life, just as it is, isn't good enough. I need to see more perfection in this moment. Give me your *best* smile." This is the exact opposite of how we want our kids to feel. No parent wants to create a performance complex in her child. But this little word "cheese" starts to breed some of that mentality. And the worst part is that children who once loved having their picture taken may begin to resist it. We must "refuse to say cheese."

Instead, try having a vision for what you are shooting. What is the story you want to tell? What are the "defining details" you want to remember about this age? What is the setting that surrounds your little one? A photo with vision captures conflict, defining details, and setting; I first discovered these three storytelling elements when I was a writer, years before I picked up the camera. But whether you have a pen or camera in your hand, the art of storytelling is the same.

When Pascaline was four years old, she was best friends with the neighbor's cat. Imagine how I would have lost the story if I had asked her to turn around and say "cheese."

CAPTURING CONFLICT

The word *conflict* can conjure up negative thoughts: siblings bickering or the toddler who only says "NO!" But storytellers often refer to conflict as action, tension, emotion, or suspense.

Pascaline was terrified the first time she tried rock climbing. As the teacher prepped her ropes and gave her instructions, you could tell she wasn't hearing a word. You may think I am a horrible parent because, instead of cheering her on, I was capturing the moment with my camera. Why capture a moment when your daughter is nervous? Glad you asked. I have a vision for the experience my children will someday have when they look at all the photos Mom and Dad took. Instead of seeing a myriad of happy smiles, I want them to see something much deeper. I want them to see who they are and who they always have been.

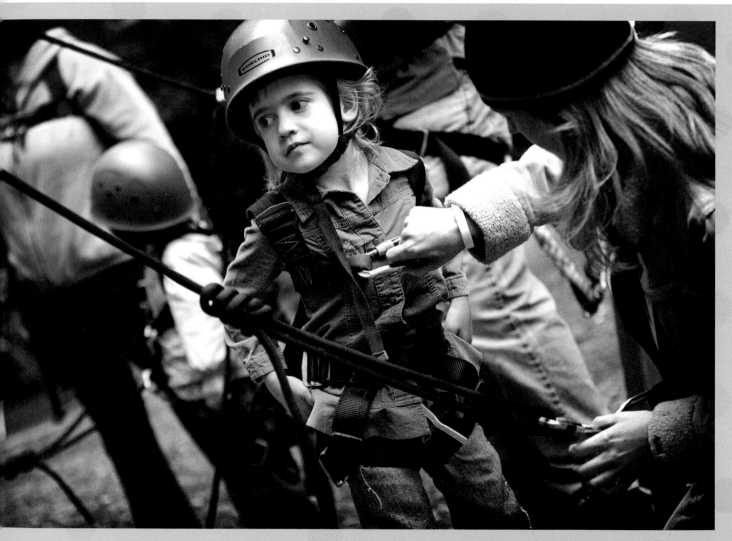

When we hear the word *conflict*, we often think of something negative. But conflict in storytelling is the turning point, the tension, the decision to move forward and face our fears.

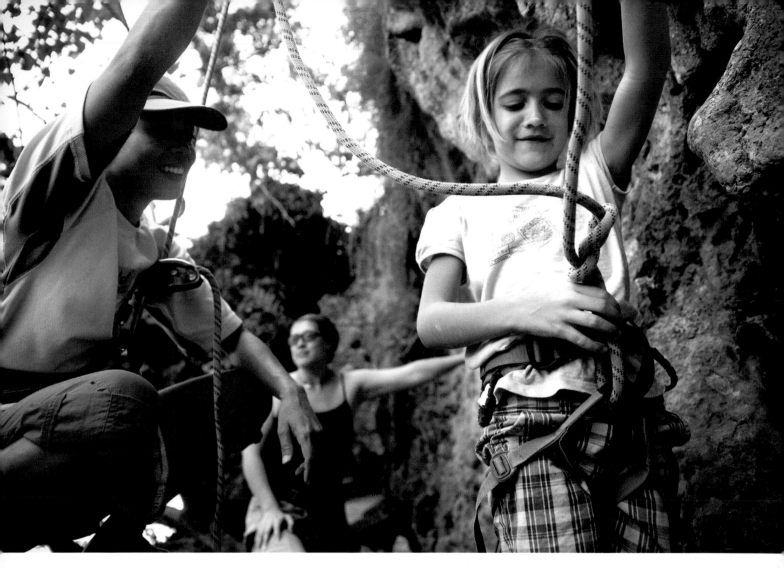

Pascaline's initial fear of rock climbing soon evolved into a passion. I want the photos of our children to be a source of inspiration. As they become older, they will be faced with moments of challenge. Photos like these show how they have had the courage to face—and overcome—their fears.

When my children become adults, they will experience moments of intimidation. I want the photos I've captured to be a source of inspiration. These photos tell the story of how even when Pascaline was five years old, she faced her fears to try something new—and if she can do that at five, she can do it at twenty-five. This is the legacy, the power, our conflict photos hold.

Now, three years later, Pascaline's initial fear of rock climbing is long gone. She is unstoppable, climbing here with her dad in Thailand. I love that we have not only photos, but a story that unfolds with her growing confidence.

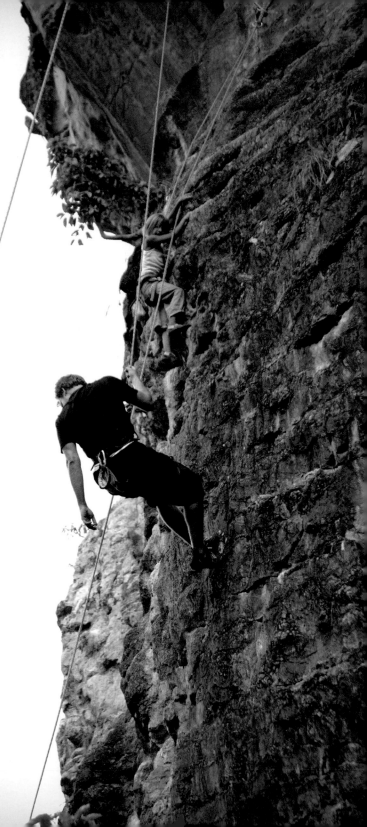

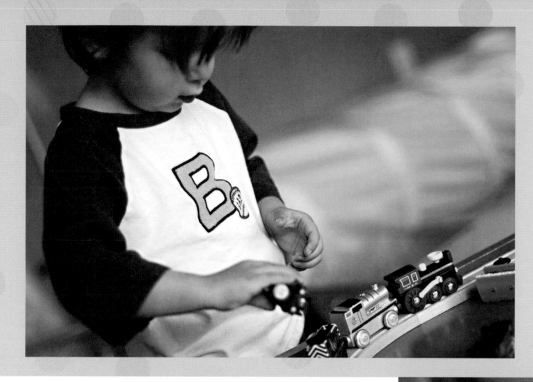

I thought Blaze's love for trains would never end, but one day it evolved into a new passion and the season of trains was over. Capturing this defining detail takes us back to when Blaze was three and walked around the house saying "choo choo!"

DEFINING DETAILS

If conflict defines emotion, defining details paint the picture. Defining details are some of my favorite elements to look for, because they invite us to slow down and look for the everyday details that surround us.

Defining details are like lines drawn in the sand that separate one season of childhood from another: from ballet slippers to cowgirl boots to dress shoes with small heels. They paint our memories with color and bring us joy as we recall all the precious seasons we thought would never end.

If your child is reluctant to have her picture taken, ask if you can do a special photo shoot of her favorite toys. This is a wonderful way to get your children excited and involved in you documenting their day-to-day life.

SETTING: BACKGROUNDS WITH A PURPOSE

Our stories need a home, a space where the action is taking place. Many people overlook this storytelling element, because they are focused on taking close-up shots of the kids. Or, they do the opposite and take pictures with way too much background. But a "setting photo" is neither one of those things. A setting photo is typically a wider shot that has just enough background to show us where we are, which adds to the story. With children, I love to capture the setting of their bedrooms, play tents, favorite chair, even their bed. Sometimes the kids are in the photo, and sometimes they aren't.

These three storytelling elements—conflict, defining details, and setting—are tools that you can play with. Capturing all of them at once takes practice, but when it happens—when you feel the conflict, see the details, and sense the surroundings as if you were there—the photo stops you in your tracks.

Now if you are like me, you read something that you "should" be doing and you start to feel stressed. You start going through all your photos wondering if you've ever captured conflict, defining details, or settings. Hit the Pause button! Phew. Let me explain.

A setting photo helps us remember where the story took place. There was a summer when the kids were in the backyard play tent every day, all day. Sometimes your children will be in the photo, but sometimes it's fun to capture their favorite place without them in it as a place marker for a specific season.

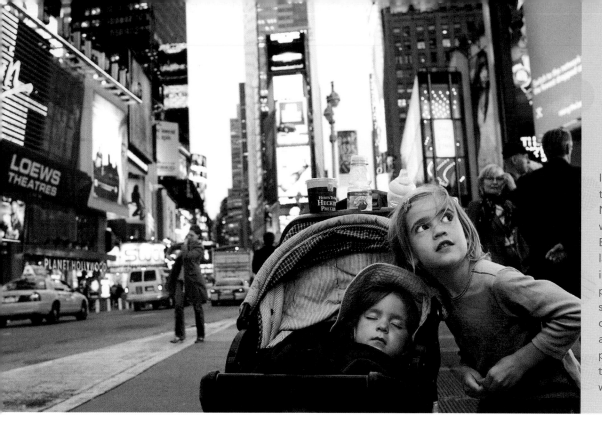

I will never forget the first time we took the kids to New York City. Pascaline was mesmerized, and Blaze was so overstimulated that he crashed in the stroller. When a photo captures all three storytelling elements—conflict, defining details, and settings—with a purpose, it comes alive, and the sounds and smells are within reach.

Over the years, I've noticed an interesting shift that takes place when parents go from photographing their babies to photographing their preschoolers. When they were capturing their babies, they loved every photo! Even if the photos weren't great, they showed them off to anyone who would look. But as their baby grew into a child, parents (especially moms) became more critical of their photographs.

We must remember that we fell in love with capturing our kids because it gave us life, a creative outlet, and a way to connect with our kids. Sometimes we get great shots with all the storytelling elements. Sometimes our photo is focused on one storytelling element. And sometimes there isn't any storytelling element, but that's your boy and you love that photo. The truth is, our children will love the photos that much more if they witnessed us loving the process of capturing them.

There is a photo of me when I was a toddler. I'm standing in my crib in the middle of the living room, wearing old-fashioned pajamas with a zipper up the middle and built-in feet. There are toys all over the floor. My dad is looking away from the camera, watching something in the opposite direction of me. I look at this photo, this imperfect, beautiful photo. I love to see all the toys on the ground. I love the 1970s-style couch and the rust-orange carpet. There is probably way too much background in the photo, but I don't notice that. I feel as if I'm looking back in time, and I love that I have this single photo.

Capturing the story of your child's life is not about taking perfect photos, it's about falling in love with the process of telling their story—being their voice. Refusing to say cheese is about giving yourself freedom to let there be a mess on the living room floor as you photograph your little girl spinning in the afternoon light with her princess dress on. This approach to photography shows our kids that we see them, really see them, and that their life—just as it is—is beautiful. So beautiful that it's worth capturing—so we never forget.

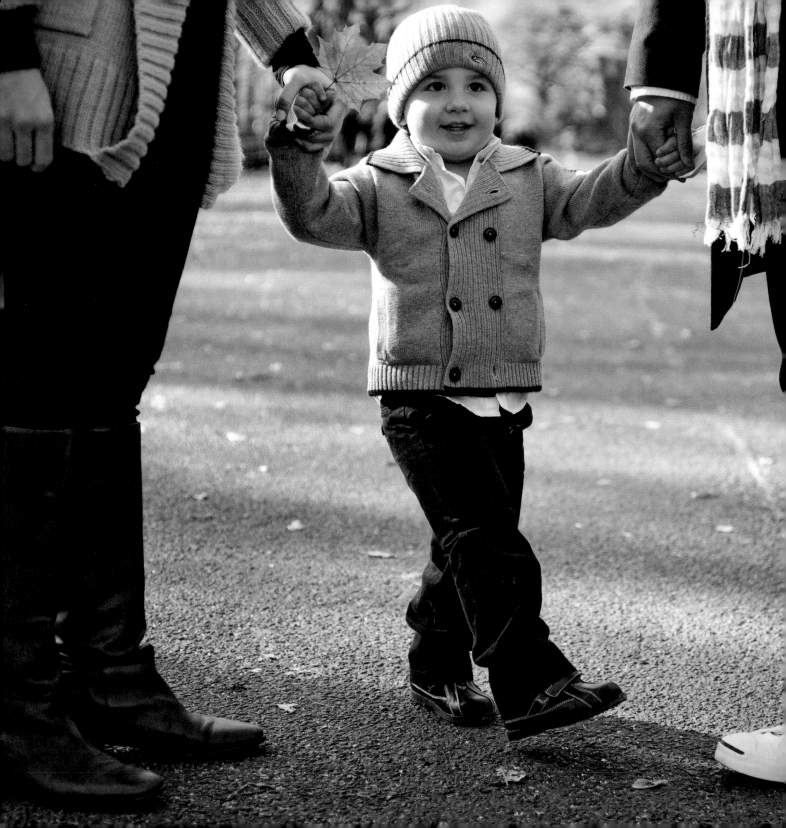

1–2 YEARS:

toddling *into* independence

> Grown-ups never understand anything for themselves, and it is tiresome for children to be always and forever explaining things to them.
>
> —ANTOINE DE SAINT-EXUPÉRY, *The Little Prince*

I shook Brian awake. "Do you hear that?!" Half asleep, he thought I was imagining noises until he heard the crash that shot him out of bed. We both stood in the dark, trying to figure out what to do. And then we heard another noise—little feet running across the kitchen floor. We both started laughing. Somehow Blaze, our eighteen-month-old, had climbed out of his crib, made it down the stairs, and was now doing God knows what. Sound familiar? Gone are the crib days when you felt somewhat in control. Hello to this new phase when your toddler wants to prove his independence at every turn. Even though this is a busy time for you and your little one, watch for wonderful developmental milestones—from mimicking Dad shaving to wanting to fly again and again (and again and again!).

five tips

for photographing your one- to two-year-old

1. **STAY ONE STEP AHEAD.** Get creative with ways to distract your toddler, such as having treats on hand, new games to play (next to a big window), and a favorite stuffed animal she loves but hasn't played with for a while (because maybe you hid it!).

2. **BECOME A HAPPY BROKEN RECORD.** Toddlers love to play their favorite games over and over again. Repeat the game with a happy face, as you create more and more time to get the shot you want.

3. **ADD AN ELEMENT OF SURPRISE.** While your toddler naps, move her favorite toys to a window. You'll set up your photos for success with beautiful lighting while also creating an element of surprise for her when she wakes up!

4. **CAPTURE THE CALM AFTER THE STORM.** Don't put away the camera too fast. Some of my favorite photos of a snuggly, peaceful toddler capture the moment just after a full-on, unleashed tantrum.

5. **INVEST IN A TOY OR DISPOSABLE CAMERA.** Toddlers love to mimic their parents. Why not get a small toy or disposable camera so your child can have a turn taking pictures after you get yours?

first steps

Those first steps represent one of the biggest milestones of your baby turning one. He wobbles, teeters, and balances as you hold your breath, anticipating his next tumble. Yet, no matter how many times he falls down, your child gets right back up, determined to figure this walking thing out! I love capturing this moment in a child's life. Facial expressions often say it all: the child is fixated, the parents frightened! Likewise, hand gestures might relay the story in a different way—those chubby little clenched fingers are caught midstride, while your hands are outstretched, ready to spot your child at the first sign of distress. Capture these fleeting details before your little guy is too confident at toddling!

WHEN: When your little one is well rested, fed, and ready to move!

PREP: You don't have to dress your child in a tuxedo, but notice how the contrast between black and white helps this little boy stand out. Ask your spouse to wear clothes that contrast with those on your child, such as light-colored pants and top if your child is in darker clothes. This will help create a seamless, nondistracting backdrop, allowing your child to stand out that much more.

FOR P&S USERS: Turn your flash off, and set your camera to Continuous Shooting mode; this will allow you to take multiple shots quickly to ensure you get one with his feet in midstep. Experiment with Sports mode to freeze the motion.

FOR DSLR USERS: Turn off your flash. Select Aperture Priority mode, and dial your f-stop down to $f/3.5$, if possible. If you are outside, take advantage of the available light and go with a lower ISO, such as 100–200, for best color saturation and richness. Double-check your shutter speed to make sure it's fast enough—at least 1/125 sec. (125)—to freeze the action of your child walking.

COMPOSE: Have your partner walk a bit off to the side, so he is not directly behind your child. A clear background gives a more independent feel to the child walking. Frame your photo so that the top third cuts off right below your partner's elbows. (When cropping part of the body out, you always want to frame right above or below the joint.) Make sure to capture your spouse's hands, ready to catch your child at any moment. They won't be sharp, but that's okay. Get down low to shoot at your child's eye level.

CAPTURE: Focus on your child's face, and shoot away. Instead of trying to walk backward while shooting at the same time, have your child and spouse (or Dad) redo their walk until you get the shot.

THE SECRET TO GREAT WALKING SHOTS

The key to a "walking" photo is taking multiple frames per second in Continuous Shooting mode to capture a picture with your child's foot in midstep; otherwise, the photo will look like the child is standing still instead of being in motion.

MY DSLR SETTINGS:
My aperture was ƒ/3.5 to soften the background. The ISO was 200 since we were outside on an overcast day and there was plenty of light. The clouds acted as a wonderful diffuser. My shutter speed was 1/200 sec. (200) to freeze the motion of this little guy's first steps.

bumps and bruises

Part of learning to walk is learning to fall. As parents, we want to protect our child from every fall, bump, or bruise—especially scratched-up, bloody knees. But no matter how hard we try, falling is part of the process. Children of all ages scrape their knees, but toddlers seem to have it the worst. How many times have you planned a get-together with friends or family, only to have your toddler take a hard fall the day before (always the day before!), leaving her to greet everyone in that pretty little outfit accessorized with scratches, scrapes, and bruises? Instead of fighting it, why not capture it?

WHEN: Within twenty-four hours of your child getting a big owie. Taking the photo right after the fall happens will most likely not go over well, but most children forget within twenty-four hours.

PREP: Find a background that is uncluttered and simple, like a row of stairs, the hedge around your yard, even the garage door. You want a simple, plain backdrop that will draw your attention to your toddler's boo-boo.

FOR P&S USERS: Turn your flash off, and set your camera to Continuous Shooting mode. Being the age your child is, she will most likely be on the move, so you will want to capture several shots at once. To soften the background, select Portrait mode.

FOR DSLR USERS: Turn your flash off, and set your camera to Continuous Shooting mode to freeze all movement. Dial your f-stop down as low as possible so that the background will have a nice buttery blur. Make sure your shutter speed is 1/400 sec. (400) or higher to freeze each bit of action without blur. If shooting outside, set your ISO as low as possible for best color saturation. If shooting indoors, you may need to bump up your ISO for more light.

COMPOSE: I'm a big believer in the Rule of Thirds (see page 53) and "off-centering," but sometimes the best place for a child is right in the middle. When capturing an action-type story like this one, I tend to go with a vertical format, because it can heighten the energy of the moment.

CAPTURE: Since you want the focus of the story to be her little, scratched-up knees, consider capturing her when she is looking away from the camera. This way her sweet face won't distract our attention from those knees. Experiment with the focus. You can either focus on the owie or her head.

MY DSLR SETTINGS:
My aperture was dialed down to $f/2.0$ to soften the concrete stairs in the background. The shutter speed was 1/800 sec. (800) to freeze the action. My ISO was 100 for best color saturation.

i want to be like you

Throughout life, we often learn best by having something modeled for us, and toddlers aren't any different. Even though they are little busybodies, they are also observers, taking in everything we do and say (sometimes to our embarrassment). Karla DiSaverio, a blog follower based in Ontario, captured the sweetness of her son Landon's curiosity with this shot of him imitating Dad shaving. If your little one isn't interested in shaving, try this same recipe for anything he loves watching you do in the mirror, such as putting on makeup, blow-drying your hair, brushing your teeth, and so on.

WHEN: A calm morning, preferably after breakfast, is a perfect time to invite your child to imitate one parent in some kind of everyday activity.

PREP: Shooting in front of the mirror is an excellent way to get both your child and your (or your spouse's) facial expressions. This bathroom had a large window that let in ample light. If you don't have a large window, turn on all of the available lights.

FOR P&S USERS: Turn off your flash to avoid glare in the mirror and harsh shadows. Set your camera to Portrait mode for a buttery, blurred background. Consider using black-and-white mode if available, especially if you have to rely on interior lighting, which might affect the color.

FOR DSLR USERS: Turn off your flash. Select Aperture Priority mode, and set the aperture low, f/1.4 or f/2.8, to soften the background and keep the foreground in sharp focus. Bathrooms tend to be tricky spots for lighting and color, so consider converting the image to black and white, which will enhance the crispness of the mirror reflection and eliminate color-balance concerns.

COMPOSE: A vertical format will beautifully frame the difference in size between your little one and Dad because their heads will be at such different heights. If you're shooting in front of a mirror, step off to the side to keep your reflection out of the frame. Also, pay attention to any light reflections in the mirror, and adjust your position to keep them out of the shot. Give your child an appropriate prop (toothbrush, hairdryer, etc.) to keep his hands occupied and add texture to the story.

CAPTURE: Focus on your child's face. If it's not in the center of the frame, reframe your image to center it, and lock in your focus. Return to your original composition and fire.

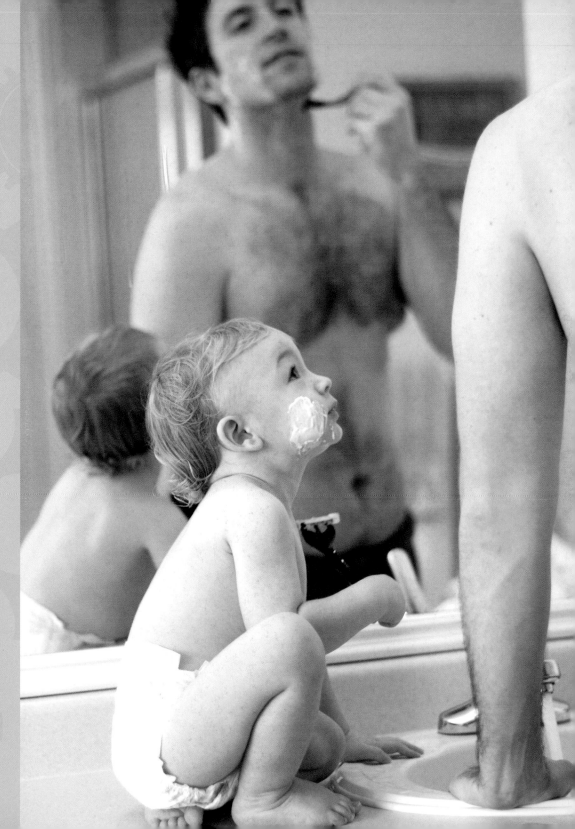

DSLR SETTINGS:
Aperture was set to *f*/1.4
for a buttery, blurry back-
ground. ISO was set to
Auto, which selected 140
because of the bright light.
Shutter speed was 1/1600
sec. (1600), as the bathroom
was flooded with light.
Photo by Karla DiSaverio

objects of affection: part 1

One of the things that has struck me most in watching my kids grow is their deep affection for different objects. From dolls to trains to special blankies, these are some of the sweetest details to look back on. They give a sense of security, comfort, and even identity as your child grows older. As these objects change, they tell the evolving story of childhood. It's easy to think of your little girl and her doll as inseparable for years to come, but it's amazing how quickly her affections will shift to something new. Capture today's objects of affection before they are forgotten.

WHEN: Right after a good cry or right before nap/bedtime. Little ones tend to be more snuggly when they are tired. In fact, you'd be surprised at the sweet photos you can capture right after a tantrum ends. Have your camera ready!

PREP: Enlist your spouse or a friend for this shot. Have him or her wear a darker color on top so that your child stands out that much more. Dress your little one in a sleeveless outfit. One- and two-year-olds are still in that sweet baby phase, and seeing their bare arms adds to the innocence of the photo.

FOR P&S USERS: Turn off your flash. Select Portrait mode so that the background will be softened. Instead of zooming in closer, step closer to your child. The closer you stand to your child when taking the photo, the greater the blur will be in the background.

FOR DSLR USERS: Turn off your flash. Put your camera in Aperture Priority mode, and dial your f-stop down to $f/2.8$ or as low as your lens can go. This will help blur the background, so all the attention is on your child's face. Step as close to your child as possible, enhancing the blur in your background.

COMPOSE: Fill the frame with your child's upper body and doll (or other object of affection). Take a moment to pause and make sure the doll's face is showing. (Seeing the back of the doll's head won't be as powerful.) Also check to see how much of the adult's head is in the photo. Maybe you want Dad's five o'clock shadow in the image, too. Or maybe you want your friend to lift her chin so that we don't see any of her but still feel a safe presence.

CAPTURE: Focus on your child's eyes. It isn't necessary for your child to look at the camera. If she is not in the center of your image, reframe your image to center her and lock in your focus by pressing your shutter button halfway down; then recompose and shoot.

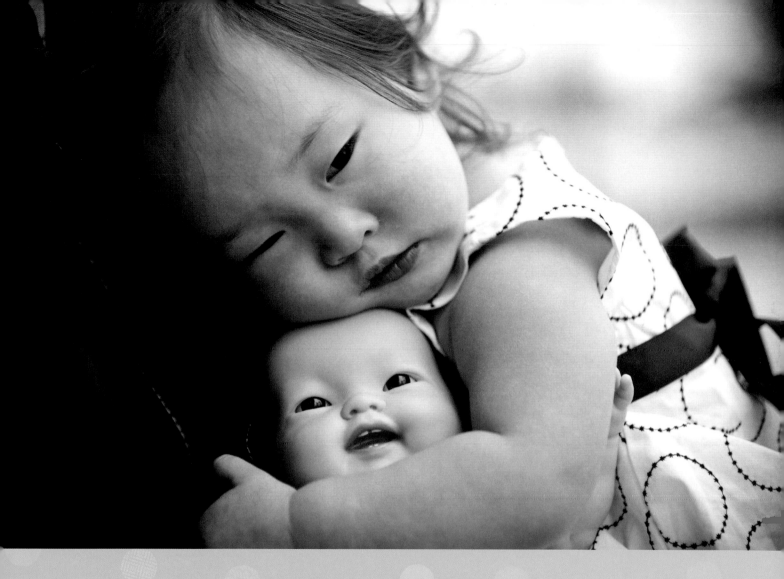

MY DSLR SETTINGS: My aperture was low, *f*/2.8, to blur the background and draw attention to this little girl with her baby doll. Since there was plenty of light, my ISO was 200 for best color saturation. My shutter speed was 1/320 sec. (320) to freeze the moment in case there was any sudden movement.

oh so dirty!

This age-group gets dirty doing just about anything. I remember Pascaline being eighteen months old and covered in spaghetti sauce and noodles, from head to toe. I lifted her, still buckled in the high chair, carried her to the backyard, and hosed her down. This memory always makes me laugh. When I saw this photo from Kelli Kalish, a former attendee and now certified CONFIDENCE Workshop teacher in Illinois, my heart burst. Her son Tucker was so dirty because he had been barefoot all day and only in a diaper. This is the age when outdoor baths (and oversized salad bowls!) come in handy.

WHEN: Morning or late afternoon, when your child is good and dirty but the sun isn't too harsh.

PREP: Try a bath outside the next time your little one is dirty. You can even create a space for your child to have fun being messy with bowls big enough to sit in. Consider stripping him down to his diaper for a more dramatic look, give him bowls of water to play with—even a snack to munch on for a dirty face—and stand back with camera ready as your child has the time of his life!

FOR P&S USERS: Turn off your flash. If your child is sitting in a makeshift "bath" like this, you won't need Continuous Shooting mode because his action will be limited. But if your child is on the move, Continuous Shooting mode is a good idea. Select Portrait mode for a blurred background.

FOR DSLR USERS: Turn off your flash. Select Aperture Priority mode, and set your aperture to $f/2.8$. Consider changing the image to black and white, as the combination of a monochrome photo and a blurred background will keep the focus on your child versus any distracting background elements.

COMPOSE: It's fine to use either a vertical or a horizontal format for this photo. Choose the one that will draw the eye to your child and tell the best story of him getting dirty. Kalish chose a horizontal format to add the dog to the image as a storytelling aspect. With Tucker in the foreground and the dog farther back, and both in the outer thirds of the frame, the eye is drawn to Tucker first before exploring the rest of the scene.

CAPTURE: Focus on your child's head. If it's not in the center of the image, reframe to center it, and lock in your focus; then return to your original composition and shoot.

THE RULE OF THIRDS

The Rule of Thirds is a composition technique for placing your child in a specific third of the frame rather than in the center. This is one way to enhance the overall feel of your story. To use the Rule of Thirds, imagine that your scene is organized by a 3 x 3 grid. Then place your child in a specific third. For instance, the primary features of Tucker's body are in the right vertical third, while those of the dog's body are in the left vertical third.

DSLR SETTINGS: Aperture was low, ƒ/2.8, to blur the busy background. The light was bright, though with some shadows, so the ISO was set to 200. The shutter speed was 1/250 sec. (250). Photo by Kelli Kalish

the shy phase

Children who are going through a shy phase, or simply have a quiet personality, are precious, bringing a quiet energy when photographed. Instead of approaching the shoot with high energy, invite your little one to show you her world. Move slowly and talk softly. Ask questions, and then affirm her answers so that she knows you are listening. Bring all of your focus to being present in this moment. Begin taking photos of her cuddling up to Mom or Dad, in her safe place. And when she is ready to take you on a journey, follow.

WHEN: When your shy one has warmed up to the camera and is feeling comfortable with leaving the security of your arms to go exploring.

PREP: Find an outdoor area that you can explore with your child. Dress your child in simple clothing and colors that contrast with the surroundings. This way, your child will stand out. I especially love how this little girl has a tank top on. Seeing her bare shoulders and arms enhances the overall feeling of innocence.

FOR P&S USERS: Turn off your flash, and set your camera to Continuous Shooting mode. Select Portrait mode so that the background she is walking toward is softened.

FOR DSLR USERS: Turn off your flash, and set your camera to Continuous Shooting mode. Select Aperture Priority mode, and dial your f-stop down to $f/2.8$ or as low as you can go. This will soften the trees in the distance. Consider decreasing the light in your photo to give it a quieter feel; to do this, simply increase your shutter speed a couple of clicks so that there is less time for light to come in.

COMPOSE: You want the story of this season of shyness to come through with beauty. Three specific compositional choices can help create this feeling: First, shoot from your child's eye level by squatting behind her, so we are brought to her perspective. Second, choose a vertical frame to enhance the feeling of the big world that surrounds her. Third, catch your child midstep, with one foot in the air; this will give the photo a stronger sense of her walking away.

CAPTURE: Since your little one is not looking at the camera, focus on the back of her head. If it's not in the center of your image, reframe your image to center it, and lock your focus; then recompose and shoot.

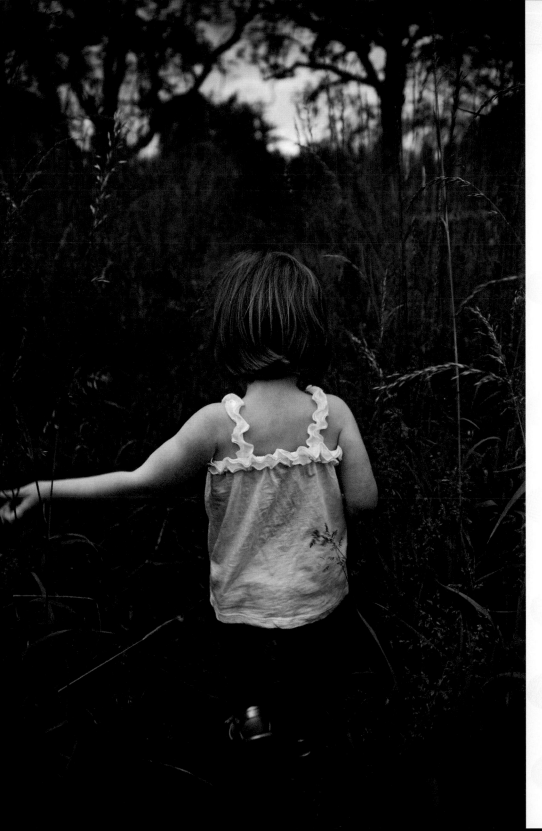

MY DSLR SETTINGS:
My aperture was low at ƒ/2.8 to blur the background. ISO was 100 for best color saturation. My shutter speed was 1/200 sec. (200) to ensure that her steps had clarity and were frozen in time for the photo.

your little chef

Playing kitchen is a favorite activity for both girls and boys at this age. I was asked the same question so many times every day that I believed I'd never stop hearing it: "What would you like me to cook for you, Mama?" I'd list off a handful of fun foods—pizza, eggs and toast, or some kind of yummy dessert—and Pascaline would run off and go to work with her kitchen toys. I'd even hear her humming as she cooked. This is one of those developmental milestones that seems never-ending, and yet it, too, is fleeting. I love how Stephanie Doran, a former CONFIDENCE Workshop attendee in Michigan, captured this little one whisking in the bowl like a pro!

WHEN: Anytime your child is absorbed with quiet, creative role-play and there are no distractions. Consider waiting until after naptime and a snack, when your child is rested and fresh for play.

PREP: This image was taken indoors on a dreary winter day. The best light in the house was a big window in the living room, so the play kitchen was moved to face the window and maximize the light. Look for the best light in your house, and relocate your "set" if need be. Sometimes putting a familiar, favorite play set in a new location stirs up excitement, which you can capitalize on for shots like this.

FOR P&S USERS: Turn off your flash, and set your camera to Continuous Shooting mode, which will allow you to grab quick bursts and follow your child as she moves. If your background is cluttered with furniture and playthings, like this one, select Portrait mode so that those elements are blurred and the focus is on your child.

FOR DSLR USERS: Turn off your flash. Select Aperture Priority mode, and dial the f-stop down to ƒ/1.8 or your lowest setting. Get in close or use a zoom lens if you want to be less obtrusive.

COMPOSE: A vertical format will keep the story's focus on your child and the task at hand. Staying tight with your framing reduces the amount of background distractions. Consider tilting the camera at an angle, as in this shot, to accentuate the energy of what's happening. The slight profile of your child can also add depth to the subject's innocence.

CAPTURE: You can focus on your child's eyes, but play around with focusing on her hands, too. Either way, keep her face in the shot. If the hands (or head) aren't at the center of the frame, reframe to center them, and lock in your focus; then reframe to your original composition and shoot.

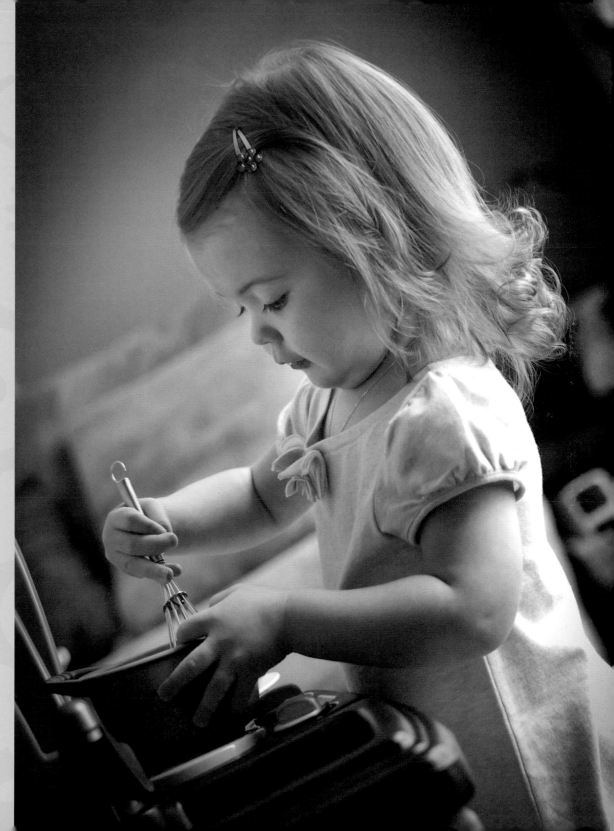

DSLR SETTINGS: Aperture was low, *f*/1.8, to blur the background and put all the focus on those busy hands. The ISO was 800, due to the low indoor light. Shutter speed was 1/125 sec. (125). Photo by Stephanie Doran

i can fly! a portrait with dad

By now you've probably started to notice the different interactions each parent brings out with your kids. The little ones are probably more likely to cuddle with Mom, but when it's Dad's turn, action is no doubt on the horizon—whether he's tickling, wrestling, or throwing them into the air. Moms tend to comfort, dads tend to play. And thank goodness for dads, because even though we all need Mama's enduring arms of love, every child wants to fly!

WHEN: When your child needs to burn off some energy and Dad is ready to help. Morning and late afternoon will give you the best results for capturing soft light, but wait until at least thirty minutes after your child has eaten. We don't want him to get sick all over Dad from flying on a full tummy!

PREP: Have Dad wear colors that contrast with your child, helping your little one stand out more. If you are doing this in the summer, have Dad wear short sleeves so that we see his bare arms. Enlist a helper to stand beside you and cheer your child on so that he looks toward the camera or straight ahead, versus looking down at Dad. If possible, we want to see all the joy on your child's face.

FOR P&S USERS: Turn your flash off, and put your camera in Continuous Shooting mode. You want the camera to take several frames per second, because the best moment is when your child is at the height of the throw. Since this is an action shot, select Sports mode, which tells your camera to use a faster shutter speed to freeze the action. Or you can select Portrait mode to ensure a softer background.

FOR DSLR USERS: Turn your flash off, and put your camera in Continuous Shooting mode. The trick is to capture this moment at the height of the throw with Dad's arms stretched upward. Set your camera to Aperture Priority mode, and dial your f-stop down as low as you can to blur the background setting and bring our attention to your little one flying. Make sure your shutter speed is fast enough to freeze the action with sharp detail: 1/125 sec. (125) or faster.

COMPOSE: Since all the energy will be moving upward, have Dad stand near trees, if possible. This will allow the boughs to reach over your child's head, adding to the feeling of him flying high. A vertical format accentuates the height of the flying even more. You can also do this photo recipe with a clear sky as your background and get underneath your child and shoot up. Have fun experimenting with different points of view!

CAPTURE: Focus on your child's face and shoot away.

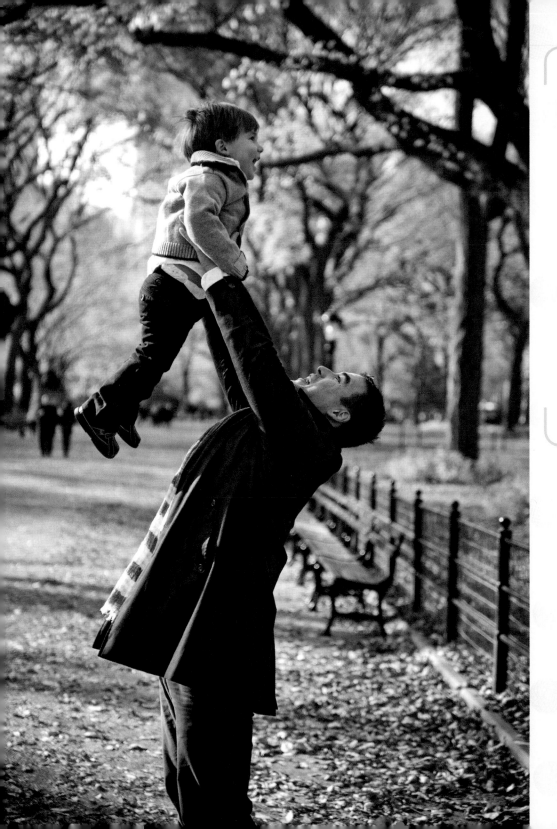

MY DSLR SETTINGS:
My aperture was set to ƒ/2.8 to soften the trees in the background. My ISO was 250 for best color saturation. My shutter speed was 1/250 sec. (250) to freeze the throw.

here's my belly button

The simplest games can create the cutest giggles. One of my favorites is asking one- and two-year-olds where their belly button is. They'll often lift up their shirt without reservation and point to their belly button with a mixture of pride and silliness. BreAnna Schumacher, a former CONFIDENCE Workshop attendee in South Dakota, captured this photo of her son, Kyron, when she was seven months pregnant with her daughter. Kyron was tickled to notice how Mama's big belly pushed her belly button out while his belly button was going in.

WHEN: Whenever the natural light is best in your house, either morning or afternoon when the sun is at an angle. And after naptime, when your child is feeling refreshed and cooperative.

PREP: Simplify the background by having your child stand near a blank wall or door, even a neutral piece of furniture with a slight amount of texture. For the best light, make sure your child is facing a window or is angled toward window light. Dress him simply. (Schumacher chose a plain black shirt to avoid distractions.) I especially love it when kids of this age are dressed down to their undies for a simplified, innocent story. Ask your child about his belly button, nose, or other body parts, and have him show you where they are.

FOR P&S USERS: Turn off the flash. Select Portrait mode to get a blurred background. Choose Continuous Shooting mode so that you can fire off multiple exposures quickly as your child moves.

FOR DSLR USERS: Turn off the flash. Choose Aperture Priority mode, and set the f-stop to f/3.5 or lower to soften the background. Since you are shooting indoors, set your ISO to 400 or 800 to ensure you have enough light. Select Continuous Shooting mode so that you don't miss a movement.

COMPOSE: A vertical format will work best here, giving you room to catch your child pointing to his belly button yet still allowing you to see his facial expression. Play around with the angles, shooting down slightly or on his level, or even shooting up slightly. Stay close and fill the frame with your child.

CAPTURE: Focus on the facial expression. If your child's face is not at the center of the frame, reframe so his face is centered, and lock in your focus; then return to the original composition and shoot. You can also try snapping a few images focused on his belly button.

DSLR SETTINGS: Aperture was set to f/1.8 to maximize the available light. The ISO was set to 400 to help add light and allow a shutter speed of 1/400 sec. (400) to freeze action. Photo by BreAnna Schumacher

family portrait: part 1

Children can have the most original ideas for a family photo! When doing a family shoot that involves a toddler, one of my favorite things to do is set up the parents and younger sibling(s), and then ask the toddler where he would like to sit. The toddler's response always surprises me. This little guy wanted to sit waaaaaaay off to the side and look in a different direction. As the parent, it can be tempting to want to interject and rearrange this photo moment. After all, this probably isn't the family portrait you may have envisioned. But this stage will end soon. Grant yourself permission to capture the humor and reality of life with a two-year-old!

WHEN: Early afternoon, when your toddler is in a playful mood.

PREP: This image requires both parents in the picture, so you'll want to call a friend for help with the actual picture-taking. (I would hesitate to use a tripod and self-timer, because you need someone behind the camera to engage the child's attention, too.) Find a colorful background for your photo, whether a vibrantly colored wall, a brick wall in an alley, or the side of a barn. Have fun and push your creativity out of the box!

FOR P&S USERS: Turn off your flash, and select Portrait mode. This will give a sharp focus to you and your partner and a softer focus to the little one sitting off to the side.

FOR DSLR USERS: Turn your flash off, and select Aperture Priority mode. Dial your f-stop down to $f/3.5$. A higher f-stop will make your toddler sharper, but this will deemphasize the fact that he has chosen to set himself apart from the family.

COMPOSE: If there is a design on the wall, like this barn has, position yourself and your family so that you complement the lines in the design. Then ask your toddler where he wants to sit or stand. A two-year-old will often subconsciously take note of where the parents are to determine where he wants to be.

CAPTURE: Ask your helper to focus on you. If you are not in the center of your frame, have her center you, lock her focus on you, and then reframe the image. Remember, we don't want the two-year-old in sharp focus.

SETTING BOUNDARIES

Children love to know where the boundaries are, because this tells them how far they can go with their independence. Knowing this, I often show two-year-olds how far away they can sit or stand from their parents (and still be in the image) when I'm organizing a family photo shoot. Try this with your little guy! Almost every time, he will choose the farthest spot, which is perfect for the story of this season.

MY DSLR SETTINGS:
My aperture was low, *f*/3.5. If I raised my aperture, the little boy would have been sharper, but in this case, the soft focus engages our attention more than a sharp focus would have. My ISO was 100 for best color saturation. The shutter speed was 1/400 sec. (400).

3–4 YEARS:

when wonder comes *before* reality

Children's games are hardly games.
Children are never more serious than when they play.

—MICHEL DE MONTAIGNE,
Essays

ne of my favorite age-groups to photograph is three- to four-year-olds. They are so full of wonder, with an imagination that is alive and rich. You can have conversations with their teddy bear, and they will believe every word their teddy whispered in your ear. Their hearts are tender (as he vows to marry Mama when he is older—sigh—such a wonderful stage) and sensitive to the world around them (as she creates an imaginary world in which her dolls can play). They are uninhibited, free from feeling self-conscious. They will dance for hours in their underwear, fall asleep in their dress-up costumes, and possibly surprise you with their own haircuts. There is such an element of magic during this phase of childhood, what better reason to document it!

five tips

for photographing your three- to four-year-old

1. **SHOOT FROM A DISTANCE.** Allow your child to stay in a place of creative play by shooting him from a distance, so you go unnoticed.

2. **ENCOURAGE A SENSE OF WONDER.** Ask her favorite teddy bear or dolls for ideas on what type of photo to take. You'll be amazed at what your child says the bear's answer is!

3. **INVITE IMITATION.** To capture your little girl spinning in her princess dress, stretch out your arms with your smile facing skyward and spin. The more you playfully model a specific action, the more fun she will have imitating you.

4. **STIR UP THE ACTION.** If your little one has a lot of energy, don't fight it. Instead take it up a notch with fun action—like tickling, being a "hug monster," and so on.

5. **LET IT BE.** Whether her hair hasn't been combed in days or her princess dress hasn't been washed in weeks, let it be, and document every authentic aspect of this stage of childhood.

my own style

Every child starts asserting preferences over clothing and physical appearance, whether she insists on wearing every mix-and-match pattern at once or refuses to brush her hair. When Pascaline was three years old, she wouldn't let anyone near her hair. The funny part is that *she* wouldn't comb it, either! For a couple years, she walked around with tangled, flyaway hair. As a parent, you learn really fast which battles are worth fighting. The battle of combing Pascaline's hair wasn't something I wanted to do every single day. Assuming (even praying) that this phase would end someday, I wanted to capture a photo of her wild hair—a defining detail that now makes us all laugh.

WHEN: Any time your child has insisted on controlling her own style, whether proudly wearing an outrageous outfit or refusing to comb her hair.

PREP: Simplify your setting as much as possible; you want all the attention to be drawn to her hair or outfit. In this image of Pascaline, a beach in the background provided a clear setting, and open shade kept her from having to squint.

FOR P&S USERS: Turn off your flash, and set your camera to Continuous Shooting mode. If your child stays put, you don't need Continuous Shooting mode, but it's always nice to be prepared in case she does move. Select Portrait mode for a buttery, blurred background.

FOR DSLR USERS: Turn off your flash. Select Aperture Priority mode, and set your aperture to $f/2.8$. If your story does not require color, consider changing the image to black and white. The combination of a black-and-white photo and a blurred background will draw attention to your child's hair or clothes that much more. If you are shooting this outside, in open shade, your flash may still want to fire as fill flash (to "fill in" the shadows on your child's face). This will tend to give the image a more commercial look.

COMPOSE: Choose a vertical format to draw attention up to your child's crazy hairstyle or wild outfit. If your focus is the hair, consider draping something (like a solid-colored blanket) over your child's shoulders to tone down any busy patterns in her clothing and draw the eye upward.

CAPTURE: Focus on your child's eyes. If they're not in the center of your image, reframe your image to center them, and lock in your focus; then return to your original composition and shoot.

SHOOTING ON THE BEACH

When you are in a beach setting, the sun reflects off the sand, making your photos that much brighter. You'll notice your camera's shutter speed will be super high to prevent too much light from getting in. Since the shutter speed is so fast, this is a great opportunity to set your ISO as low as possible—ideally ISO 100— for the best saturation and color vividness. (The hint of grain in my image of Pascaline occurs because I shot this with film. This is one of the unique characteristics I miss most when shooting digital.)

MY DSLR SETTINGS: My aperture was low, ƒ/2.8, to blur the background. It was a bright, sunny day, so I set my ISO to 100. My shutter speed was 1/2000 sec. (2000).

mommy and me

Do you ever feel like you are "missing in action" when it comes to photos of your child? If so, you're in good company. I meet countless moms who feel this way. They are often the ones taking the pictures, and as a result, there isn't any evidence that they were even there! Hand this photo recipe over to Dad or a trusted friend. We are going to walk them through all the steps to not only getting you in the photo but helping you shine!

WHEN: Take this photo early in the day, after breakfast when the light outside is neutral to avoid harsh shadows from bright sun, or right before afternoon naptime when the child wants to snuggle with Mom.

PREP: Have Mom wear something she feels beautiful and comfortable in. Her level of comfort will show up in the photo much more than the pattern or design of her clothes. Ask Mom and child to sit down—either on the ground or in a chair, on a bench, etc.

FOR P&S USERS: Turn your flash off. Set your camera to Portrait mode. This will tell your camera to focus on the subjects and soften the background. If the little one is moving around a lot, set your camera to Continuous Shooting mode to freeze the action.

FOR DSLR USERS: Turn your flash off. Set your camera to Continuous Shooting mode. Choose Aperture Priority mode, and dial your f-stop down to f/4.5. This wider-than-normal f-stop will help ensure both subjects are in focus while simultaneously creating a buttery, blurry background.

COMPOSE: I usually opt for a horizontal format for photos of moms because the wide frame gives a calmer feel than does a vertical format. The most flattering way to capture Mom is by shooting down on her. Most women also don't want their whole body in the photo. It is often more appealing to frame Mom from the waste up; so get in close, and fill the frame with Mom and child. Close any gaps between their bodies by having them snuggle up to each other. The closer their physical bodies are, the more intimate the photo feels.

CAPTURE: Focus on either Mom's eyes or the child's eyes versus having both their faces in focus. This draws more attention to the photo's story. Experiment with different viewpoints for Mom. Have her look at her son and smile so that you can capture a nice profile of her smile. Have both of them hold something, like a storybook, that they can look at together. Encourage Mom to keep talking with a smile and even give you a laugh here and there. She may feel awkward, but it will look genuine in the photo. (Tell her I said so if she doesn't believe you!)

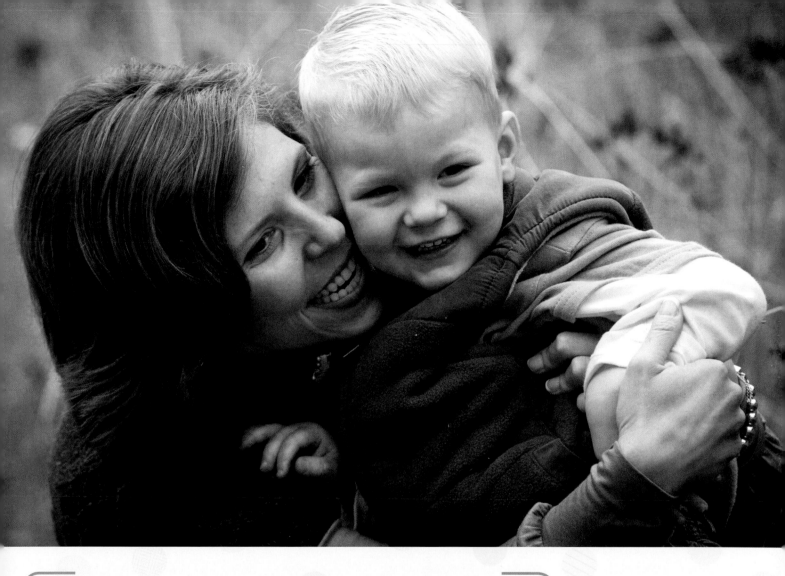

PHOTO STORIES WITH MOM VERSUS DAD

Considering the many types of families I've photographed, it is amazing that there is one overarching commonality: moms like to snuggle in close with their children for photos; dads like to be captured doing some type of action—tickling, making silly faces, learning to ride a bike, and so on. As you compose a photo of your partner, consider these dynamics and try to capture the truest story of his or her relationship with the child.

MY DSLR SETTINGS: My aperture was $f/4.5$ to make sure both Mom and her child were in focus. ISO was 200 for best color saturation. (I ended up turning the image to black and white, and the low ISO generated deep, rich black-and-white tones.) My shutter speed was 1/200 sec. (200) to capture their expressions and actions in detail.

potty training

One of the biggest developmental milestones for a three- or four-year-old is being potty-trained. Children often seem to warm up to the idea of potty training when no one is looking. One day, Melissa Calder, a former CONFIDENCE Workshop attendee in Washington State, realized it was awfully quiet in the house and decided to check upstairs. She found her son stripped naked and sitting on the toilet. So she grabbed her camera and tried to hide at the end of the hallway. He spotted her and flashed a smile—caught in the act!

WHEN: Any time when things are quiet and you catch your toddler going about his business. Wait for a time when sitting on the potty has become a fun, relaxed affair, not a forced struggle.

PREP: If possible, position yourself outside the bathroom door. If your bathroom doesn't have ample natural light, use any available interior lighting to illuminate the room. Switch off any hallway lighting so that the bathroom will be brighter and central to the story's focus.

FOR P&S USERS: Turn off the flash. Select Portrait mode to keep the aperture low. Since you are shooting from a distance, enable Face Detection if your camera has that option. This way your camera knows you want to focus on your child's face versus the doorframe in front of him.

FOR DSLR USERS: Turn off the flash. Select Aperture Priority mode, and dial down the aperture to $f/2.8$. Because of the high contrast between the dark hallway and the light bathroom, set your camera to Spot Metering mode. This tells your camera to get enough light for whatever is in the center of your frame (in this case, your child's face). Take a couple of photos, and see if your image is too dark or too bright. If your brightness needs to be adjusted, write down your shutter speed and then switch to Manual mode. Adjust your shutter speed, by speeding it up or slowing it down to take away or add light.

COMPOSE: Vertical framing emphasizes the doorway without getting too much of the hallway in the image. Get down low, at eye level with your child.

CAPTURE: Focus on your child's face. If he catches you in the act of shooting, his surprise will show. If his face is not at the center of your composition, reframe your image to center it, and lock in the focus; then return to the original composition and shoot.

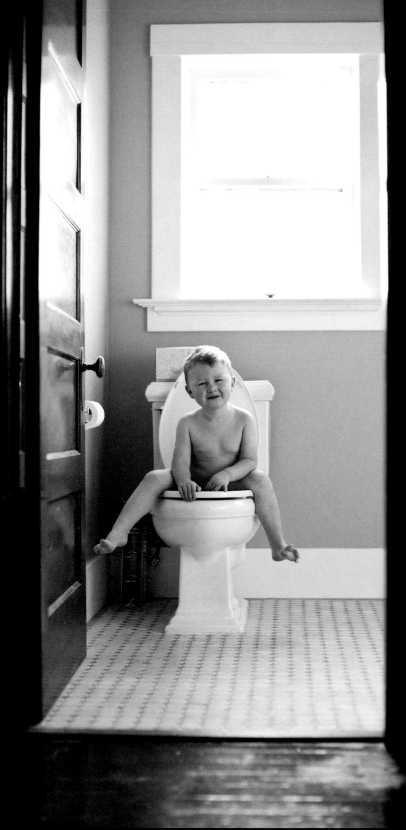

TIPS FOR SHOOTING IN HALLWAYS

Dark hallways can be a great way to lead the viewer's eye into a bright, sunny room. To accentuate this effect, turn off the hallway lights, so your main source of light is the room your child is in. Stand at the opposite end of the hallway, and experiment with zooming in, varying the degree of how much "hallway" you have in your frame. Try kneeling down so that you are at eye level with your child, which will make the hallway and doorway feel that much more encompassing.

DSLR SETTINGS: The aperture was set to ƒ/1.8 to allow as much light in as possible, and the shutter speed was set to 1/250 sec. (250). The ISO was 800 to bring in more light and compensate for the dark hallway and shadowed foreground. Photo by Melissa Calder

DIY haircuts

I remember this afternoon like it was yesterday. I had to make a quick trip to the grocery store. Brian was home with the kids (totally Dad's fault). When I got home, I found Barbie hair all over the living room floor. It didn't take a rocket scientist to realize that Pascaline had found the scissors and given all her dolls haircuts. But, boy, was I in for a surprise when I turned the corner and saw that she had turned the scissors on her own hair! When I share this story with women in our workshop, they often send me their own photos. It seems that a DIY haircut is a four-year-old's rite of passage. We'd better make sure we capture it!

WHEN: After the shock has subsided. The fears that race through your mind of what "could have happened" as you picture your child holding scissors to her face are maddening. The best time for you to take this photo is after you have calmed down and can see the humor in it all. Give yourself a few days, if need be. No judgments here—boy, do I get it!

PREP: Find a simple background for this photo so that nothing distracts from her haircut. You might position your child near a window or bring her outside.

FOR P&S USERS: Turn off your flash, and set your camera to Continuous Shooting mode. Set your camera to Portrait mode for a softer background.

FOR DSLR USERS: Turn off your flash, and set your camera to Continuous Shooting mode. Put your camera in Aperture Priority mode, and dial your f-stop down as low as you can. Being able to blur the background will create an empty, almost quiet space in the photo's story.

COMPOSE: Fill the frame with your child's hair and face, and then experiment with off-centering. Leaving a bit of empty space to one side draws our attention to her hair even more. A horizontal photo was the only way for me to go on this one. I wanted the uneven cut of her bangs to be accentuated by the straight line of a horizontal format.

CAPTURE: Notice how Pascaline's eyes have a soft focus? This is because I focused on her uneven bangs instead of her eyes. In turn, this made her eyes feel that much stronger. Center your focus on the part of your child's hair that you want to capture. It could be her bangs, the uneven line of the hair down her back, or a side profile. Once you've grabbed your focus, reframe your image and shoot away.

TRICKS FOR A BUTTERY, BLURRY BACKGROUND

You don't need a fancy lens to blur the background if you understand a little about depth of field. Think of a "force field," as in *Star Wars*. Everything in the "force field" is in focus, and everything outside of it is blurry. The size of the "force field" (or depth of field) is set by aperture, the distance between subject and background, and the distance between photographer and subject. So to get a blurrier background, try moving closer to your child. Or, move her farther from the background.

MY DSLR SETTINGS: My aperture was as low as I could go, *f*/1.4, for two reasons. I wanted the back door to be a blurred, empty space behind her. This extremely low f-stop also allowed me to get her uneven bangs in sharp focus and her eyes, being slightly behind her bangs, in a soft focus. The ISO was 100 for maximum color saturation. My shutter speed was 1/1250 sec. (1250).

best friends

There's nothing like the love between a child and a pet—whether it's a dog, cat, rabbit, or even a tiny hamster. How many times have you caught your child playfully rolling around on the floor with your puppy, intently serving tea to your disinterested cat, or nuzzling your family pet? When your pet responds, validating their special bond, magic fills the air. Why not capture these moments of pure affection? Here, Allison Gallagher, a former attendee and now a certified CONFIDENCE Workshop teacher in Virginia, captures Atticus midhowl, while Sammi squeals with laughter at his side.

WHEN: Anytime your child shows prolonged interest in your pet and is calm enough to sit and focus on some puppy or kitty love.

PREP: Simplify your setting as much as possible. An indoor room flooded with window light or a covered outside porch is ideal. If your pet is high energy, take him to the park for a quick run so that he will be mellowed out for the photos. Have treats on hand for your pet (and child—better not leave him out!) as a reward for a job well done.

FOR P&S USERS: Turn off your flash. Set your camera to Portrait mode to get that blurry background. If your child and pet are content to sit still, you probably won't need Continuous Shooting mode, but it's a good option to consider if there's a chance one or the other might go mobile.

FOR DSLR USERS: Turn the flash off. Select Aperture Priority mode, and dial down the f-stop to $f/2.0$ for a blurred background that doesn't distract the viewer from the focal point of the image—your child and pet. Try to get an exposure with a fairly fast shutter speed, so you won't get any blur on your subjects if they move. If the shutter speed is too low, try increasing the ISO until it speeds up, at least 1/125 sec. (125) or faster.

COMPOSE: A horizontal format will best accommodate your child and pet if they're side by side, but experiment with a vertical format if your child wants to hold your pet. If you're shooting on a porch, use the floorboards as leading lines to draw the eye in toward the center of the frame. Squat down to shoot at your child's eye level, and get in close, so your focus is on the expressions.

CAPTURE: Focus on your child's face. If it's not in the center of the frame, reframe the composition to center the face, and lock in your focus; then reframe to your liking and snap the shot.

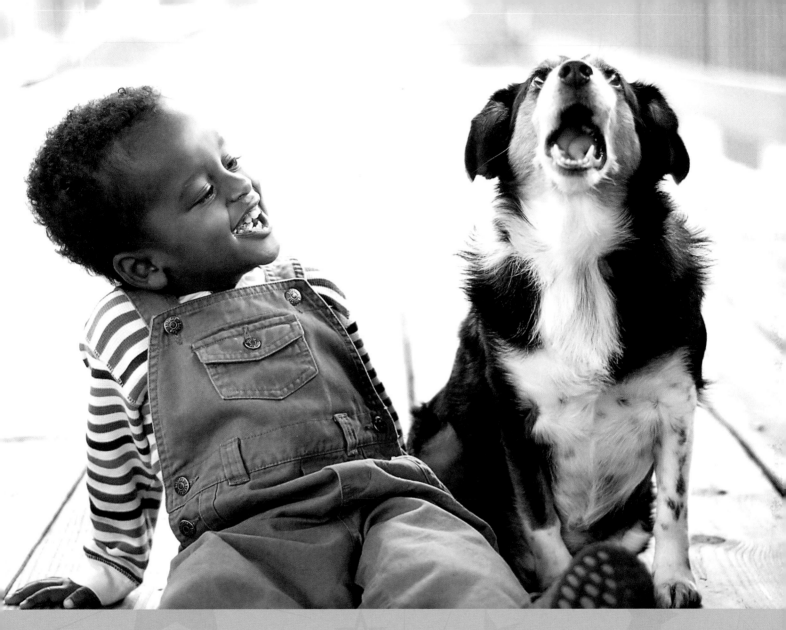

DSLR SETTINGS: The aperture was dialed down to ƒ/2.0 to blur out the background details and keep our attention on Sammi and his best friend. Shutter speed was 1/125 sec. (125) to freeze the action. The ISO was set to 400. Photo by Allison Gallagher

i love to dance!

Some of my most precious memories of Pascaline being three years old are when I would catch her dancing in a room by herself. She didn't need music to twirl her dress, skip, and sway her arms. A child's fearless innocence, uninhibited and free to dance, is an inspiring story to capture. For this photo recipe, DSLR users will have to shoot in Manual mode, but never fear, we will take it one step at a time.

WHEN: The drama in this photo is enhanced by the lighting. Observe the morning and evening sunlight throughout your home. When does it come spilling through your windows and/or glass doors? That's when you want to take your photo.

PREP: Dress up your little one in clothing that light can shine through, and have her stand in front of the window or door. Turn off all the lights in the room. The contrast between the bright outdoor light and dark interior will enhance the drama in your photo's story.

FOR P&S USERS: This photo is difficult to capture with a point-and-shoot, but you can get close by doing the following steps: Turn your flash off, and set your camera to Continuous Shooting mode. Select Portrait mode. Focus on your subject. If she becomes dark (due to the bright background), touch your subject on the LCD display screen. Many smartphones and compact cameras now have a touch-screen feature that enables you to brighten the area you touch to avoid a silhouette.

FOR DSLR USERS: First, turn off your flash, and set your camera to Continuous Shooting mode. Next, set your camera to Aperture Priority mode, and take the photo. If your photo is a silhouette, your shutter curtain is opening and closing too fast. It's okay. Write down the shutter speed that your camera chose. Now switch to Manual mode. You need to slow your shutter speed down to let more light in, so roll your shutter speed dial a few clicks to the left. Take another photo. Keep adjusting the dial until you have enough light.

COMPOSE: If your background is a glass door, like mine, a vertical format will allow you to capture the full height of the door. If you are taking a photo of your child in front of a bay window, a horizontal format may be more flattering. Have fun experimenting, depending on the type of dancing your child is doing and the room you are in.

CAPTURE: Focus on your child's face. If you don't want your child's face in the center, hold your shutter button halfway down, and then reframe the image so that your child is off-center and take the photo.

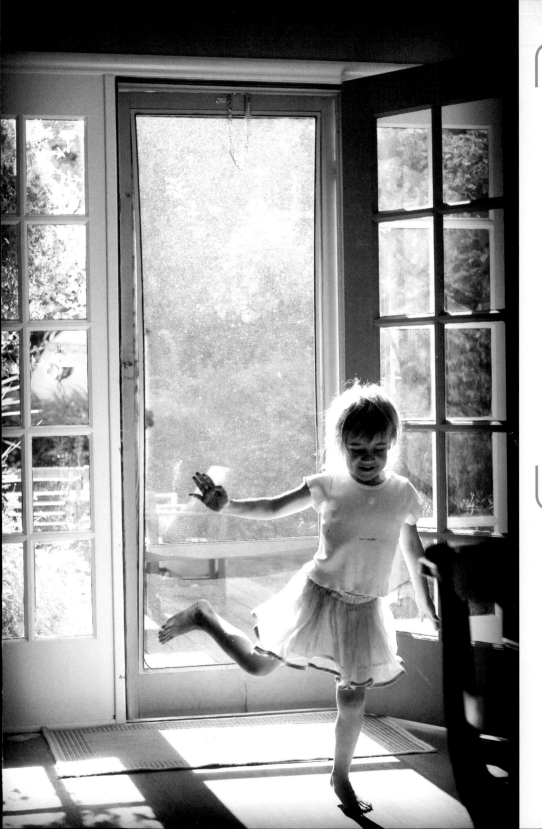

MY DSLR SETTINGS: My aperture was low, ƒ/2.8, to soften the background. The ISO was 400 for good color saturation and also capturing movement. The shutter speed was 1/1000 sec. (1000) to freeze the moment with sharpness.

79

tea parties

Even though Pascaline is now approaching her teenage years, we still have tea together and talk about everything and anything. When she was three or four years old, I loved finding her in the bedroom with her teacups set up for her and her stuffed animals. When Julie Staub, a blog follower in Ohio, sent me this photo, I loved the dynamic of multiple girls, all cousins, having a tea party. Why not set up a shoot for which your daughter and her stuffed animals are invited to dress up while Mama documents the festivities?

WHEN: Midmorning, when sunlight isn't too far overhead and harsh, or later in the afternoon when the sun dips down to a low angle. Consider shooting in open shade if conditions are too bright.

PREP: Place a quilt or picnic blanket in front of a pleasant background (under a tree or in a flower garden), with an eye toward horizontal framing. Set the scene before bringing out your children. Prop up the teddy bear so that he's sturdy and stable and just off-center. Lay out the tea set. If you're shooting a range of ages, make sure the littler ones are well-rested and have a snack as part of the setup to keep them occupied.

FOR P&S USERS: Turn off your flash. Set your camera to Aperture Priority mode so that the background is gently blurred. With multiple children, Continuous Shooting mode will let you take multiple frames quickly, so you don't miss an expression.

FOR DSLR USERS: Turn off your flash. Select Aperture Priority mode, and dial the f-stop down to between $f/1.8$ and $f/4.5$ (depending on your lens) to bring in the most light and blur out distant background details. Back far enough away from the scene to get everyone's face in focus. (The farther you are from your subjects, the lower you can go in f-stop and still have more faces in focus.)

COMPOSE: Horizontal framing works best for a small group of children, getting in enough of the surrounding greenery to complete the story. If it's just your child and teddy, play with vertical framing. Wait for the moments when your children are involved with tea pouring or talking. Use the tiltable feature of Live View or lie down on your stomach in the grass so that you can shoot straight on.

CAPTURE: Focus on the center-most, tallest child's face. If the children are close enough together in the lineup, they should all be in focus. If the tallest child isn't in the center of the frame, reframe your shot to center her, and lock in your focus; then return to your original composition and shoot.

DSLR SETTINGS: Aperture was set to f/1.8 to blur out the background, and the ISO was at 200 to bump up shadows slightly without losing color saturation. The shutter speed was 1/640 sec. (640). Photo by Julie Staub

objects of affection: part 2

Now that your child is older, take a new portrait of him with his favorite toy or best "stuffed" friend, this time enlisting his suggestions. When I first met Parker, he held his teddy close. After getting acquainted, I asked if I could talk to Teddy. "Teddy, what would be a fun idea for a picture?" I asked, and then put him up to my ear and oohed and aahed. I asked if he would tell Parker his idea. Parker lifted Teddy to his ear, smiled, and nodded in agreement. Then, without hesitation, Parker lay down on his belly and set Teddy on his belly, so they were facing each other. I heard his mom sigh. We were witnessing the vivid imagination of a boy with his teddy. Why not do the same with your child's teddy (or other favorite soft toy) and watch the magic unfold?

WHEN: When your child is rested and fed during the morning hours or late afternoon. Since this photo recipe will enlist your child's imagination, try to stay away from sugar before the shoot. Sugary cereals and snacks tend to cloud the vividness of a child's imagination.

PREP: Invite your child to pick his favorite stuffed animal for a "special photo shoot," and explain that you need his help. Ask Teddy what photo he has always wanted to have just of the two of them. Respond as if you hear Teddy talking to you, and then ask Teddy to share his idea with your child. If your child doesn't want to play, don't be discouraged. Instead, keep the conversation going with Teddy for a future day when your child wants to engage.

FOR P&S USERS: Turn off your flash, and set your camera to Continuous Shooting mode. This way, if your child is in motion with his stuffed animal, you can capture several frames a second.

FOR DSLR USERS: Turn off your flash. Select Aperture Priority mode, and bring your aperture down to $f/2.8$. You want the background blurred so that all the attention is on your child and his stuffed animal.

COMPOSE: Whether you choose a horizontal or vertical format will depend on your child's idea. When Parker lay down on the ground with his teddy, I knew I wanted the photo to be as wide as possible to see the full length of his body in comparison to his little teddy. I also squatted down to shoot at eye level with Parker and Teddy. Adjusting your eye level helps bring the connection between your child and his teddy to the forefront.

CAPTURE: Focus on your child's face or eyes, if possible. If he is not in the center of your photo, reframe your image, and lock in your focus; then return to your original composition and shoot away.

MY DSLR SETTINGS: My aperture was low, *f*/2.8, to blur the steps and structure behind Parker and his teddy. I set my ISO to 100. My shutter speed was 1/400 sec. (400). This was plenty fast to freeze the action if there was any unexpected movement on Parker's part.

my favorite costume

Three- and four-year-olds can become so entranced by their costumes that even sleep won't break the spell. Stacy Gendreau, a former CONFIDENCE Workshop attendee in Washington State, captured this moment of her little boy, who was in love with his hot-air balloon pilot costume. One night she went to check on him and found that he had changed out of his pajamas and back into his costume.

WHEN: After your child has fallen asleep in his favorite costume. If your child is still napping, the lighting will be much better. Bedtime is more challenging because of the darker conditions.

PREP: To compensate for the low lighting, turn on a nearby table or bedside lamp. If your child is easily awoken, try soft lighting from a short distance away—a hallway light may do the trick—or bouncing a flashlight off a wall. You may even want to sneak in a small tripod or brace yourself against the wall to prevent any blurring from camera shake. You can also rest the camera on a nearby table or nightstand.

FOR P&S USERS: Turn off the flash. Select a higher ISO setting if possible, or select Night Portrait mode (but make sure it doesn't enable the flash).

FOR DSLR USERS: Turn off the flash. Start with Aperture Priority mode, and dial your f-stop down as low as possible for not only a blurred background but also the largest aperture opening to allow the most light. Take a few shots. If your child is too dark, switch to Manual mode, and raise your ISO and slow your shutter speed down. Take another test shot. If your child's face is still too dark, keep slowing your shutter speed down until you have enough light on his face. But keep an eye on the shutter speed—anything lower than 1/60 sec. (60) is hard to handhold without blurring the moment. That's when you raise your ISO again or use a tripod or nightstand to rest your camera on.

COMPOSE: Vertical framing works in this shot, because the child's hands are extending outward. A horizontal frame might work if your child is sleeping in a different position. Get in as close as you can without disturbing your child's slumber, but be sure to show enough of the costume to tell the story. If the sheets and covers have a busy pattern, frame your shot to crop them out as much as possible.

CAPTURE: Focus on your child's face. If it's not at the center of your composition, reframe your shot so that it is, and lock in your focus; then reframe and quietly shoot away.

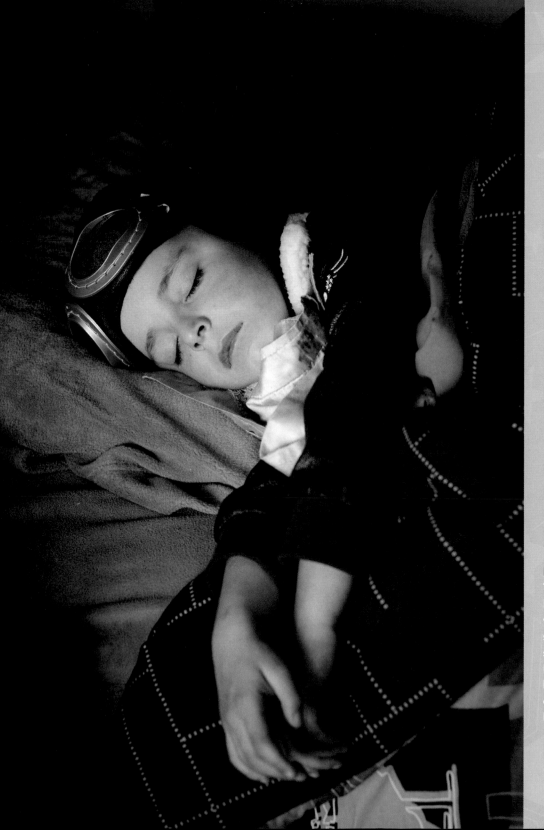

DSLR SETTINGS:
The aperture was set to $f/2.8$ to let in as much light as possible, with the ISO at 500 to help speed up the exposure. Shutter speed was 1/80 sec. (80). Spot Metering mode was used to keep the light correctly metered on the boy's face (see page 23). Photo by Stacy Gendreau

family portrait: part 2

If you asked your child where she wanted to sit for a family photo when she was a toddler, try asking the question again when she is three years old. I have found that once children turn four or five, they become conscious of what is socially expected and try to fit in. But the three-year-old doesn't need to fit in. She wants everyone to understand that she is her own person—independent, capable, and in charge. Try giving your three-year-old a say in the matter the next time you take a family portrait. While it may not be the photo you expected, it will perfectly capture the spirit of your child at this age!

WHEN: In the morning after breakfast when the kids are rested, fed, and feeling cooperative. Be sure to start early enough so that you can avoid the noon hour when the sun is directly overhead, causing horrible shadows and eye squinting.

PREP: Since this image requires the whole family, you will want to call a friend for help with the actual picture-taking or set the camera on a tripod and use the self-timer. Bring a couple of props to play with. We carried this bench and child-size chair into an open field near the family's house. Plan your picture-taking around morning or late afternoon to avoid harsh shadows from a midday sun, or take advantage of a cloudy day when the light is even and soft.

FOR P&S USERS: Turn off your flash, and set your camera to Continuous Shooting mode; this allows you to take multiple shots, so you'll get one with everyone's eyes open. If your background is obstacle-free, like this one is, you can also select Landscape mode; this will help you get everyone in focus. If you'd rather have a buttery, blurry background, switch to Portrait mode.

FOR DSLR USERS: Turn off your flash. Select Aperture Priority mode, and dial your f-stop down to $f/3.2$. Have your friend stand six feet away from your family and zoom in if there is too much room on either side. You want a blurry background but also to have everyone in focus. The more distance there is between your camera and your family, the lower your friend can go with the f-stop and still have everyone's face be in focus.

COMPOSE: Consider a horizontal format to give enough room for everyone in your family, plus a little extra on either side so that you can fit the image in a standard-size frame (like 8 x 10 inches).

CAPTURE: Ask your friend to focus on your eyes. If you aren't in the center of the frame, she should reframe the image to center you and lock in the focus; then return to the original composition and take the shot.

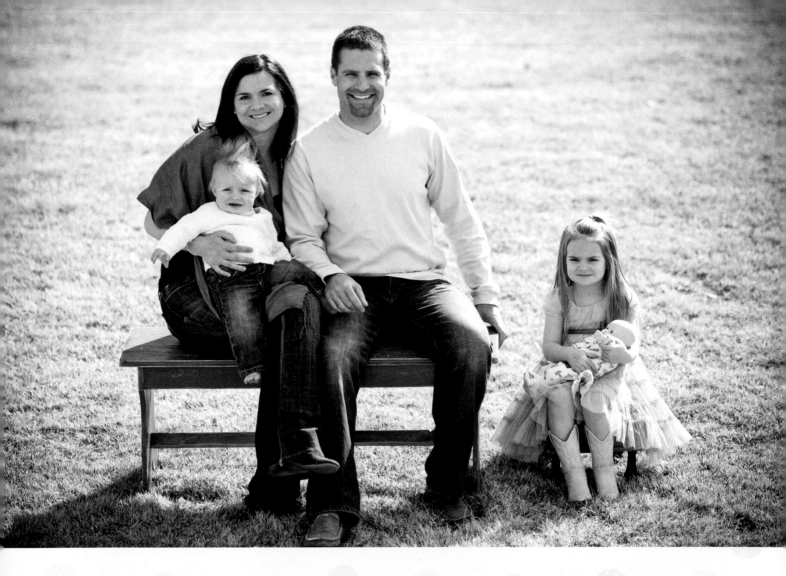

MY DSLR SETTINGS: My aperture was wide, f/3.2, to ensure a buttery, blurry background. My ISO was 160 for best color saturation. Even though I converted the image to black and white, I still wanted the richest tones possible that come with a low ISO. My shutter speed was 1/2000 sec. (2000) because of how bright it was.

5–7 YEARS:

leaving *the* circle *of your* arms

> How far that little candle throws its beams!
>
> —WILLIAM SHAKESPEARE,
> *The Merchant of Venice*

Up until now, your child probably hasn't ventured much beyond arm's reach and your protective embrace. But kindergarten is on the horizon, and everything is about to shift. The life of a five- to seven-year-old is filled with big transition, what I refer to as a "crossover stage" for both child and parent. Your five-year-old may still have wonder-filled ideas about the Tooth Fairy and Santa Claus, but by age seven she has likely crossed over into practical explanations. And yet, this period is also full of new adventures and bold courage—like spending time alone under the quiet of his blanket fort or learning to ride her bike. Every step of your child's journey is beautiful, tender, and alive with memories that will fill your heart for years to come.

five tips
for photographing your five- to seven-year-old

❶ DISTRACT THE LEFT BRAIN. To help your child relax around the camera, ask him a question about his favorite book, TV show, or movie. By distracting the mental, left side of the brain, you can help your child forget he's being photographed.

❷ DISARM THE FAKE SMILE. Many children this age give a fake smile for photos. To avoid this, ask the child to close his eyes. Then wait for his face to relax. Once it does, tell him that on the count of three he should look right into the camera lens.

❸ SET A TIME LIMIT. If your child is resisting having her photo taken, build her trust by setting a short time limit and sticking to it. This way your child knows there is an end, and she will be that much more open to the camera.

❹ GET GOOFY! When all else fails, resort to body humor. This age loves the funny sounds the body makes—especially the "stinky" sounds! Look for smartphone apps to help you out or take your child by surprise.

❺ GIVE LOTS OF PRAISE. If your child is aware of you taking his photo, tell him how much you enjoy capturing his personality and all the cute and silly things he does.

first day of school

The first day of school is always a wonderful milestone to capture. You want to get that shot of your child looking at the camera and smiling. But don't stop there. Go on to capture the rest of the story—how this day feels from her perspective. I remember Pascaline's first day of kindergarten. Another child had told her that she had to know how to tie her shoes before she could come to kindergarten. Pascaline took this literally and thought she couldn't enter the classroom until she had figured it out. I found her sitting outside the class door, trying to tie her shoes. This is a story that our family will never forget.

WHEN: Throughout the morning on the first day of school.

PREP: Ask your spouse or a grandparent or friend to come with you on the first day of school. This way your child will feel like someone is attentive to her big day, while you have a little more freedom to look for the significant stories to capture.

FOR P&S USERS: Turn off your flash, and set your camera to Continuous Shooting mode. Set your camera to Portrait mode for a softer background.

FOR DSLR USERS: Turn off your flash, and set your camera to Continuous Shooting mode. Set your camera to Aperture Priority mode, and dial your f-stop down to a low number, like $f/2.8$. This way you can capture photos with your child in focus and the background story blurred.

COMPOSE: Take a moment to pause and look for the story of this big day. What are key elements that are significant? Are there kites hanging from the ceiling bearing each child's name, lunchboxes in the cubbies, etc.? Base your photos around those elements—combined with any action. Look for lines, like a row of desks or a row of coats, that can lead the eye to your subject. So many details are involved with a child's classroom that you can easily have too much background. That's why the pause is important. Find the story, and then frame everything else out of the photo.

CAPTURE: The activity that your child is doing will determine your focus point. Since Pascaline was intent on tying her shoes, I decided to focus on her hands, because that's where the story lives for this photo. If you are taking a photo of your child at her desk, you could focus on her eyes and let all the desks in front of her and behind her be blurred.

MY DSLR SETTINGS: My aperture was wide open, ƒ/2.8, so that the door behind Pascaline could have a softer focus. I wanted all the attention on her. The ISO was 400. My shutter speed was 1/100 sec. (100).

the light in your child's eyes

Your five-year-old may seem all grown up compared to his toddler years. After all, he can skip, talk your ear off, and get dressed all on his own. But kindergarten teachers will be the first to tell you how much five-year-olds love to cuddle and be tender. There is an innocence about this age that is wonderful to capture as they transition into being big kids and going to school. Why not capture it with a beautiful portrait?

WHEN: During the early or late afternoon when the window light is soft, even an overcast day will work magic. Look for those special moments when your child is feeling cuddly-snuggly, like after reading a book together or during quiet time.

PREP: Position the couch, chair, or bed so that your little one can face the window light. It doesn't matter what he is wearing or how messy the room is. All that matters is that you have nice, even window light to illuminate his face.

FOR P&S USERS: Turn off your flash, and select Portrait mode so that the background will be soft.

FOR DSLR USERS: Turn off your flash, and select Aperture Priority mode. Dial down your f-stop as low as possible so that you have the most buttery, blurry background possible. When shooting indoors, it is sometimes best to start at ISO 400 to ensure you have enough light for your photo. You can always lower your ISO if the room is bright enough.

COMPOSE: Have your child face the window light to create "catchlight" in his eyes. This is the beautiful white light in the center of the eye that shines back at you. Catchlight adds depth to your child's eyes. Get close to him to fill the frame with his face, or zoom in with your lens. Make sure there isn't anything in the background that will distract from the moment.

CAPTURE: When taking a close-up photo of your child, focus on the eye that is nearest to you. The other eye will not be as sharp, but that's okay, because when we look at a photo, we notice the eye closest to us and subconsciously ignore the other eye.

MY DSLR SETTINGS:
My aperture was low, ƒ/2.0,
to create a soft, but-
tery blur—not only in the
background but in all the
other details of his hair, ear,
and neckline while keeping
a sharp focus on the eye
closest to the camera. The
ISO was 400, and my shutter
speed was 1/125 sec. (125).

playground antics

Playgrounds bring out the joy in children but can be challenging places for picture-taking, because the equipment can so easily distract from the essence of the photo story. With this photo, Eleni Bastounis, a blog follower in Michigan, struck precisely the right balance. Just one look at the joy all over this little boy's face and we know exactly where he is! If you have felt discouraged about your playground photos, roll up your sleeves, and bring your camera and this photo recipe with you!

WHEN: Bright sunlight is a plus to capture the fun bokeh (the sun flares). Avoid straight overhead, midday sun, and opt for late morning or early afternoon, when the sun is at a slight angle. Make sure your child is in a playful mood.

PREP: Ask a friend or your spouse to join you and watch over your child so that you are free to look for photo stories. Scout around the playground to find unusual, surprising angles. Park yourself underneath a play structure and angle your camera up. Think about the placement of the sun, and play around with angles to capture bokeh. You can often see the sun flares in your lens as you allow a little bit of direct sunlight to hit your lens. For a pose like the one shown, wait for your child to get to the top of a play structure, or invite him to play a game of peek-a-boo for a surprised-looking expression.

FOR P&S USERS: Turn your flash off. Set your camera to Portrait mode to blur the background. Or select Sports mode to freeze the action. Select Continuous Shooting mode if your child is on the move.

FOR DSLR USERS: Turn off the flash. Select Aperture Priority mode, and dial down the aperture setting to let in more light and blur the background. You want a blurry, overexposed background with a fast enough shutter speed to freeze action. Take a test shot. If you find that you want your image a little bit darker or brighter, make note of your camera settings and switch to Manual mode. Now slow down or speed up your shutter speed to finesse the light where you want it.

COMPOSE: If shooting up at a play structure, get into a comfortable position where you can wait for the shot. Play around with horizontal and vertical framing, depending on the size and shape of the play structure and where you hope to catch your child. Keep framing close so that neither playground equipment nor background distracts from the focus of the image. Try to fill the background with the sky for simplicity.

CAPTURE: Focus on your child's face. If it's not in the center of the frame, reframe the shot to center the face and lock in the focus; then reframe to your original composition and shoot.

KEEPING YOUR PHOTOS CRYSTAL CLEAR

Have you ever taken photos in bright sun and had your pictures come out looking foggy or hazy? This is caused by too much direct sunlight hitting your lens. To avoid this, use your hand to block some of the light as a lens hood would—or as an extension to the lens hood you are using. It's a free and easy fix!

DSLR SETTINGS: The shutter speed was set to 1/1600 sec. (1600) to freeze the action. The aperture was set to $f/2.5$ to blur the background and blow out the highlights there. ISO was set to 160. 28mm lens. Photo by Eleni Bastounis

the evolution of your child's shoes

One of the most playful ways to document your child's life is through the evolution of her shoes! Over the years, my kids have had favorite shoes—whether it was the cowgirl boots with pink flowers that Pascaline wore every day or the Vans with flames that Blaze called his "blazing shoes." Shoes are a detail you could easily forget to capture, because your children have them on every day. However, when you look back on all the different shoes they've loved, you will see not only the evolution of their shoes but the evolution of their personalities!

WHEN: You can do this photo any time of day. Even if the kids are fussy, we'll never know!

PREP: Have your kids roll up their pants or wear colorful tights with leggings. We want to make sure we can see all of their shoes. Head outside, or take advantage of a big window, with toes pointed toward the window.

FOR P&S USERS: Turn off your flash, and set your camera to Portrait mode. Or, experiment with the Tulip icon, a shooting mode for taking macro photos, since this is a close-up shot. Either one of these modes will focus on the foreground and soften the background.

FOR DSLR USERS: Turn off your flash, and set your camera to Aperture Priority mode. Dial your f-stop to $f/2.8$. If you go lower, your camera may focus on the shoestrings or the front of the shoe. If you don't have a low f-stop, like $f/2.8$, but you want a blurry background, get as close to the shoes as possible when taking the picture.

COMPOSE: A horizontal format is often my favorite way to go when it comes to capturing kids' shoes. We were at the beach when I shot this photo. There was a grassy bank above the beach. I had the kids stand up there while I stood below. This way, I was able to shoot the shoes straight on—and even a little bit up. By using a low f-stop, I blurred the grass in the foreground on purpose to draw the eye to the shoes even more. Play with your environment, and look for a point of view that you wouldn't normally use.

CAPTURE: Focus on any of the shoes. If they are lined up on the same line, they will all be sharp no matter which one you focus on.

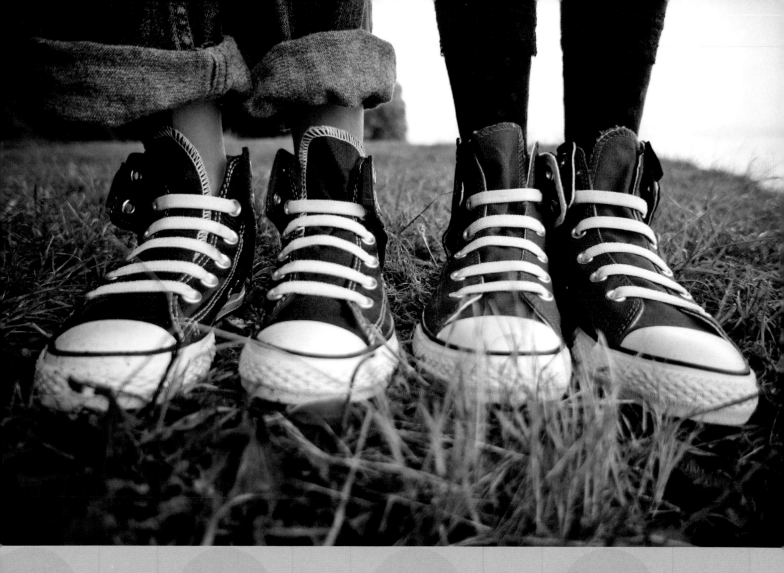

MY DSLR SETTINGS: My aperture was low, ƒ/2.8, to blur the background and bring all the attention to the shoes. ISO was 400. My shutter speed was 1/200 sec. (200).

young artist

Your child works so hard on every drawing and is so excited to give each one to you. Why not capture him in the act? At this age, you may feel like he will always have a crayon or marker in hand. (After all, isn't your refrigerator absolutely covered with his creations?) But for most, this stage of childhood will be fleeting, too, when you look back on it. Shirley Lange, a former CONFIDENCE Workshop attendee in Washington State, captured this precious moment of her grandson on a quiet afternoon.

WHEN: Any time your child is in a quiet, artistic mood and soft light is coming in through a window or door.

PREP: Set your child's desk or table facing a window so that you have as much natural light as possible. Feel free to arrange the table before he sits down to color. You want the story of this photo to be clear and full of coloring accessories (white paper, scissors, markers, and so on). Allow space and time for your child to become absorbed by his imagination.

FOR P&S USERS: Turn off the flash. Set your camera to Aperture Priority mode so that the focus stays on your child. You don't need Continuous Shooting mode if your child is still, but it's always good to enable the mode in case he begins to move around.

FOR DSLR USERS: Turn your flash off. Set your camera to Spot Metering mode and Aperture Priority shooting mode. Dial your f-stop down to $f/4$ or lower to capture the most light. Take the photo. Is your child too dark or too bright? Make a note of the shutter speed that your camera chose. Now switch your camera to Manual mode, and pick either a slower or a faster shutter speed than what your camera chose (depending on whether you need more or less light in the photo). If the lighting isn't so bright, consider supplementing with a table lamp or increasing your ISO to 400.

COMPOSE: Stand back and zoom in so that you don't distract your child and lose the quiet moment. A horizontal format will work best, as it will allow you to capture both your child's face and his work of art. Keep the Rule of Thirds in mind (see page 53), and frame your child's head slightly off-center.

CAPTURE: When capturing your child drawing, you can take a few different approaches. You can always focus on his eyes. But you can also get in front of him and focus on his hands while letting his face be blurred in the background. Give yourself freedom to play around with different viewpoints and focus points.

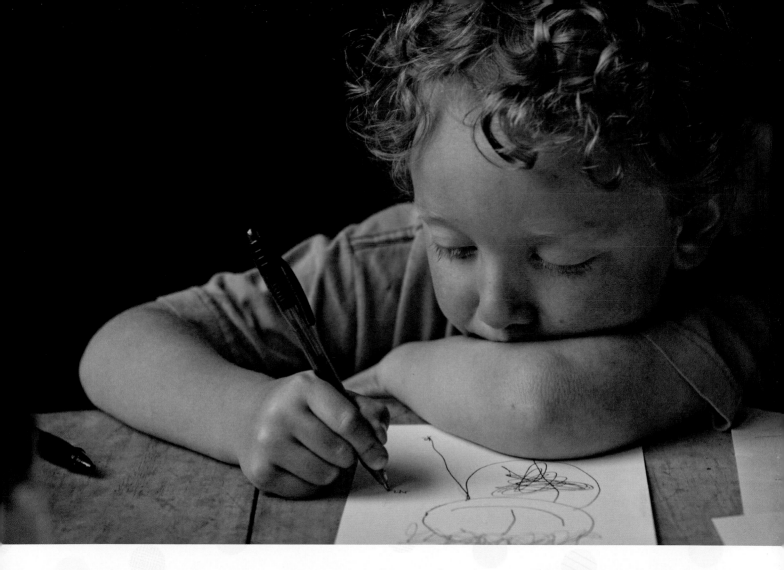

DSLR SETTINGS: The aperture was set to ƒ/4, which is slightly high. (Shirley was standing very close to her grandson, which allowed the background to be blurred.) The shutter speed was 1/100 sec. (100), and ISO was set to 200 for best color saturation. Photo by Shirley Lange

blanket forts

Childhood isn't complete without blanket forts. When Blaze was five years old, he went through a stage when he would make a new one every day. I tried taking a few photos of them, but the lighting was often horrible because the forts were between the back of our couch and the wall. One day I decided to shift things by inviting Blaze to build one with me in front of the big bay windows in our home. Little did he know that Mom was setting herself up for a more successful photo! Before your child retires the blankets and fort building, invite him to build one with you by a large window for a photo that beautifully captures this creative stage of childhood.

WHEN: Late afternoon or early evening, a few hours before sunset.

PREP: The trick to this photo is strong backlighting. Find the brightest room in your home at this time of day, and build a blanket fort with your child in front of the window.

FOR P&S USERS: Turn off your flash, and set your camera to Portrait mode. If your child is too dark in the image, many smartphones and compact cameras now have a feature that allows you to touch the subject's face on the LCD screen to tell the camera you need more light on it. Other models have an HDR feature that captures three images (backlight, shadows, and so on) and blends it into one image. Play around with both to avoid getting a silhouette result.

FOR DSLR USERS: First, turn off the flash. Next, set your camera to Spot Metering mode and Aperture Priority shooting mode. Dial your f-stop as low as you can go, and take the photo. How does it look? Is your child a silhouette? Is the window in the background blown out? Make note of your shutter speed. If your window isn't blown out or bright enough, switch to Manual mode and slow down your shutter speed even more. Keep adjusting your shutter speed, a couple of clicks at a time until you get the result you want.

COMPOSE: The magic of a blanket fort is all in the draping of the blankets and sheets. You want the blankets to feel like they extend forever, because this makes your child seem even smaller. Consider a horizontal format to accentuate the feeling of your child being hidden under all the draping.

CAPTURE: Focus on your child's face. If he is not in the center of your image, reframe to center him and lock in your focus; then return to your original composition and shoot away.

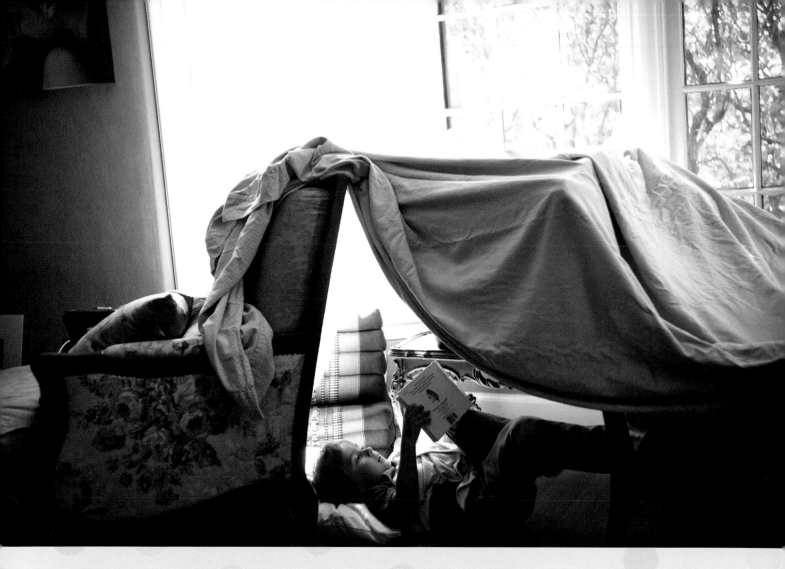

NOTICE THE RITUALS

With his world changing and school becoming a greater presence in his life, your child no doubt craves the consistency of daily rituals. For some kids, this means building a new blanket fort every week; for others, it means riding a bike every afternoon. Capture not only your child but your child in the midst of doing the rituals that bring him a sense of security.

MY DSLR SETTINGS: My aperture was low, ƒ/2.8, to blur the background but also allow as much light as possible, since I was shooting inside. ISO was 320. My shutter speed was 1/80 sec. (80).

taking off the training wheels

There is something frightening yet magical when you first let go of the back of your child's bike and watch her wobble down the path. Before you know it, she is independently trekking along, and those training wheels are a distant memory. As a parent, you know that the act of letting go while staying close enough to help with the fall is an ever-evolving story. This photo by Nicole Elliott, a former attendee and now a certified CONFIDENCE Workshop teacher in North Dakota, shows how this milestone can provide a wonderful opportunity for a symbolic capture.

WHEN: Morning, late afternoon, or early evening, when the light isn't too harsh. Make sure your child is in a cooperative mood and not too nervous.

PREP: Pick a location with low traffic. Position yourself so that the light is coming from behind you or off to the side. Get low to the ground and wait for your child and helper to pass through the frame.

FOR P&S USERS: Turn off the flash. Select either Sports or Action mode. This will use faster shutter speeds to freeze the action and prevent blur. If these are not available, select Portrait mode. Choose Continuous Shooting mode so that you can rapid-fire the shutter as your subjects roll through the frame.

FOR DSLR USERS: Turn off your flash. Choose Aperture Priority mode, and select a low f-stop (f/2.8 or lower) to blur the background and put the focus on your subject. Set the ISO to 100. If your child's face isn't bright enough, switch to Manual mode and slow down your shutter speed. Since your child will be making many attempts, you can play with the shutter speed to find the one that freezes action without losing too much brightness. Select Continuous Shooting mode to take multiple exposures quickly as she passes through the frame.

COMPOSE: Horizontal framing will give you room for ample foreground and background. Position yourself far enough away so you have time for multiple exposures. Have them pass left to right (or right to left, depending on the position of the sun). If you lie on the ground, you will get some blurred foreground in the shot, which directs the eye toward the center of the frame where the action is. Lying low while shooting up also gets more sky in the background, reducing any distracting background.

CAPTURE: Focus on your child. If she's not at the center of the frame, reframe to center her and lock in your focus; then reframe to your original composition. Snap away as she passes through the frame.

LEAVING ROOM FOR DO-OVERS

Learning to ride a bike is an emotional experience for both you and your child. As much as we want to document this milestone, we also want to be emotionally (and physically) present. This is a process, and it isn't critical to capture the first time. Children often need a couple of weeks to practice their pedaling before the wobbliness is gone. There is no shame in asking for a do-over with your child—and they often love another chance to show off their newfound bike-riding abilities.

DLSR SETTING: The aperture was set to $f/2.8$. ISO was set to 100 because of the bright sunlight and to capture the most vivid color. The shutter speed was fast, 1/1000 sec. (1000), to freeze the action. Photo by Nicole Elliott

favorite toys

At this age, kids often have a go-to toy—and it can be the darnedest thing. For Blaze, it was a slingshot, and his attachment stemmed from necessity. Brian and I had rented a house in the jungles of Thailand, and we lived there as a family for six weeks when Blaze was five years old. Little did we know that monkeys would ransack our house every other day. We are talking banana peels all over the floor, spilled rice, clothes everywhere . . . you name it! We were on the verge of giving up hope, but the locals gave us some hand-carved slingshots. The monkeys weren't afraid of people, but they didn't like being pinged in the bottom with a rock. Alas, slingshot practice became a daily exercise for the kids! Sometimes it can feel like your kids are surrounded by toys, but take a moment to capture the ones that stand out because they are connected to a story or experience.

WHEN: Early morning or late afternoon when your child is rested, fed, and feeling playful. Avoid photographing around noon, when the sun is overhead, causing harsh shadows.

PREP: Find a chair or bench that you can stand on so that you can shoot down on your child and his favorite object.

FOR P&S USERS: Turn your flash off. If your photo is all about the toy, get in close and treat this photo like a macro shot by setting your camera to the Tulip icon. This setting is for capturing details while blurring the background. Since you are doing a close-up of your child's favorite object, see if you like the results of the macro shooting mode.

FOR DSLR USERS: Turn your flash off. Select Aperture Priority mode, and set your f-stop as wide as possible to get maximum blur behind the toy. If your child is moving or you have low lighting, bump up your ISO to 400, which will allow a faster shutter speed to freeze action without sacrificing vivid color.

COMPOSE: Choose a vertical or horizontal format, depending on the shape of your child's object. Instead of zooming in with your lens, stand as close as possible to your child's object. This will enhance the blur of your child's face and body in the background.

CAPTURE: Focus on the object and shoot away.

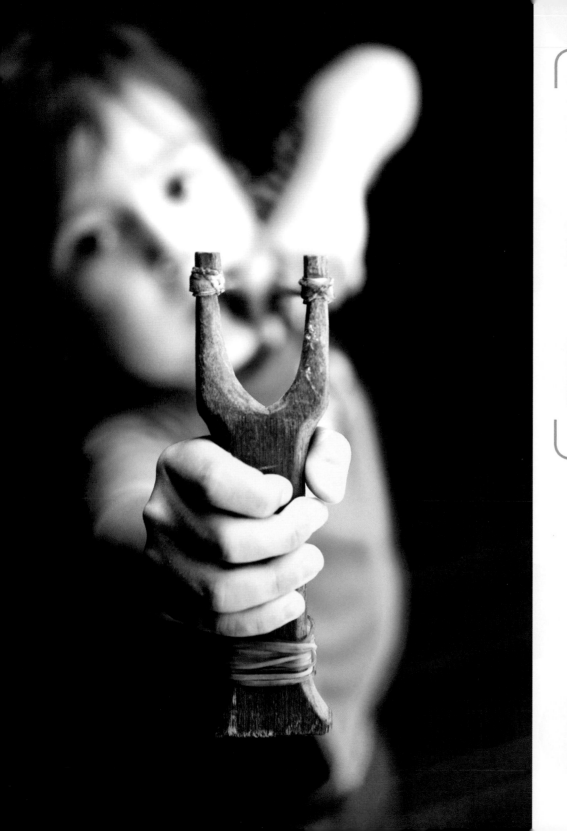

GETTING THE RIGHT BLUR

Notice how blurry Blaze is behind the slingshot? His face is this blurred because of how close I was standing to him when I took the photo. The closer you get to your subject, the more blur there will be in the background, regardless of the f-stop or whether your camera is a point-and-shoot or DSLR.

MY DSLR SETTINGS: My aperture was as open as my zoom lens could go, $f/2.8$, to soften the background of Blaze's face. ISO was 400. The shutter speed was 1/125 sec. (125).

bye-bye, baby tooth

A wise woman who had been a kindergarten teacher for more than thirty-five years once told me that when a child's first tooth falls out he often realizes that nothing lasts forever. This developmental stage is something children tend to internalize, mulling around as they anxiously consider how quickly or slowly the rest of their teeth will fall out. And then the Tooth Fairy comes, and all is right in the world again. I love how Bethany Ann Fleishour, a blog follower in Ohio, not only captured her son's joy—but also the tooth and the hole it left in his smile!

WHEN: Capitalize on that initial excitement, and find the best lighting in your house at that moment. Since this is an unplanned event, the lighting may not be ideal and you may have to improvise.

PREP: Have your child pinch the tooth between his fingers to show the size of it in his little hand. If you're shooting indoors during the day, find good lighting by a window. For this photo, the sun was fading, so Bethany had her son stand by the open front door to maximize those last rays of late-afternoon sunlight. If you're shooting at night, use strong directional light from a lamp.

FOR P&S USERS: Turn off your flash. Select Portrait mode for a blurry, buttery background. Since this is a detail photo, you can also experiment with the Tulip icon—the macro setting. This will ensure focus on the detail (tooth) and blur in the background.

FOR DSLR USERS: Turn off your flash. Set the camera to Aperture Priority mode, and dial down the f-stop to $f/3.5$ or lower to blur the background and force the focus onto the tooth. If you're shooting indoors in low lighting, bump up your ISO to 400.

COMPOSE: Horizontal framing gives you enough room to off-center the clasped tooth and still have your child's toothless grin in the background. A dark background behind the tooth helps bring it into focus. Be sure to ask your child to show off his new smile.

CAPTURE: Focus on the tooth. If it's not at the center of your composition, reframe the shot to center the tooth, and lock in your focus; then reframe your original composition and fire away.

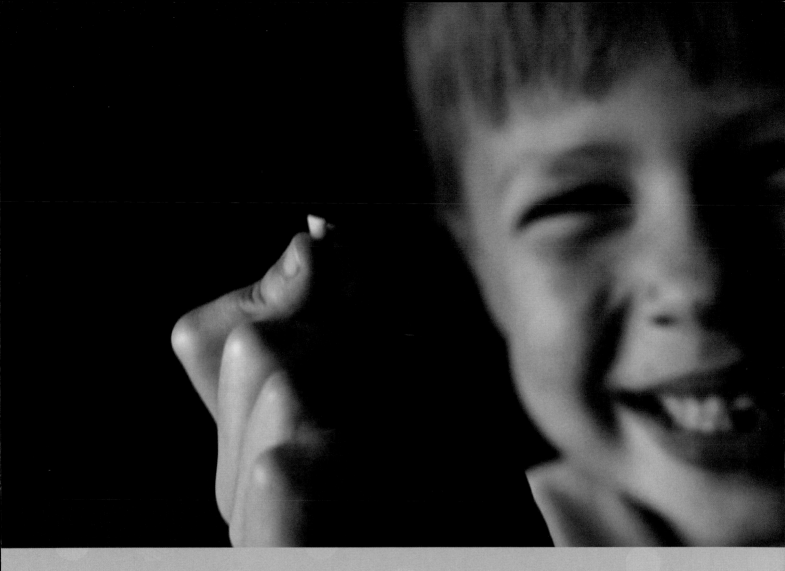

DSLR SETTINGS: The aperture was
f/3.5 to blur the background. A slow
shutter speed of 1/40 sec. (40) let
more light into the dark background.
The ISO was 800 because of the
low lighting. Photo by Bethany Ann
Fleishour

pretend play

Your child's rich imagination and sense of wonder doesn't go away when she starts school. It expands! When Pascaline was three years old she wore a princess dress all the time. When she turned five, six, and then seven, she was noticing more of the world around her. Instead of being fond of princesses, she was intrigued by cowgirls, superheroes, and especially villains. When she put a costume on, she was that character and no longer Pascaline. This is such a fun developmental time to capture! As your child's awareness of characters and personalities deepens, she becomes that much more able to step into character at any given moment.

WHEN: After breakfast or in the late afternoon when the sun is not overhead.

PREP: Help your child put together a character costume. Think of different ways to accessorize the outfit. You don't need to buy a costume. Sometimes the best dress-up outfits are homemade.

FOR P&S USERS: Turn off your flash, and set your camera to Continuous Shooting mode so that you can better freeze the action. Set your camera to Portrait mode for a soft, blurred background.

FOR DSLR USERS: Turn your flash off, and set your camera to Continuous Shooting mode to capture every bit of action. Set your camera to Aperture Priority mode, and dial down to a low f-stop. You'll notice that my f-stop wasn't as low as I normally go. Since I was shooting from a distance with a zoom lens, the background became as blurred as if I were shooting at $f/2.8$.

COMPOSE: Vertical formats tend to feel more energetic. If action is happening, I often find myself framing the moment as a vertical. Pause and do a quick scan of the background. Position yourself so that there is a solid background behind your child that won't distract from her character. Solid backgrounds can be walls, hedges, trees—anything with a repetitive pattern that will blend well when blurred.

CAPTURE: Focus on your child's eyes. If they're not in the center of your image, reframe your image to center them, and lock in your focus; then return to your original composition and shoot away.

USING A TELEPHOTO ZOOM LENS

When kids are in character, I like to be sneaky about taking their photo. If they see me, they sometimes shift their play to be more "acceptable." This is when a telephoto zoom lens comes in handy. My favorite one is the 70–200mm F2.8 lens. I can crack open the back door, zoom in on the kids playing, and take photos without them ever knowing or—most importantly—leaving character. Zooming from a distance also gives you a buttery, blurry background without having to go as low with your f-stop!

MY DSLR SETTINGS: My f-stop was $f/4$, which doesn't seem low enough to get a blurry background, but because I was standing far away and zooming in, I was able to achieve a blurred background. ISO was 100 for best color saturation. My shutter speed was 1/160 sec. (160).

8–10 YEARS:

giving *your* child

voice

> Share with children works of the imagination. . . . They invite children to go within themselves to listen to the sounds of their own hearts.
>
> —Katherine Patterson,
> *A Sense of Wonder*

For many parents, picture-taking slows way down at this age. Your child is now in school all day and may be approaching that awkward preteen period; however, every stage of childhood unfolds into a new phase of adventure, development, and creativity. The most wonderful part of photographing this age is the opportunity to creatively collaborate with your child. When you ask her for a photo idea, you not only capture her ideas but you also empower her creative voice and, ultimately, her confidence. The gift you've given her by capturing her childhood now becomes a gift of creative confidence that will continue to grow inside her in years to come. Who knew the act of photography could evolve into something so powerful for our children?

five tips
for photographing your eight- to ten-year-old

1 **INVITE CREATIVE COLLABORATION.** Ask your child to brainstorm ideas with you for a photo theme or setup. Throw out ideas that are from left field, especially silly ones, to give her freedom to think outside the box.

2 **ASK FOR PERMISSION.** This age group can feel self-conscious with all the physical and emotional changes taking place. Create a dynamic of respect by asking for permission to photograph him as he reads, plays, or works.

3 **ALLOW FOR PREP TIME.** Be spontaneous with your picture-taking, but also allow for moments when you give your child prep time. Daughters may especially want to run to the bathroom and check their hair or outfit. Respect the authenticity of her age.

4 **BE THE CHEERLEADER.** Bring your camera to all of your child's games and special events to show how much you are cheering him on.

5 **HAND THE CAMERA OVER.** One of the most power-ful ways to cultivate your child's imagination and develop her creative voice is to hand the camera over and ask her to capture the world as she sees it. Be prepared to be inspired!

your child's heritage:
a portrait with grandma or grandpa

My Korean father was an eighth-degree black belt. In recent years, he lost his left leg when a teenage driver was texting and didn't see him. His determination to stay strong while recovering has been an inspiration to the whole family. When I asked if I could take a photo of him with the kids dressed in their tae kwon do uniforms, my mom offered to find his old black belt in the attic. The kids were thrilled! Consider past or present passions that your kids share with their grandparents, whether it's playing checkers or baking, to create a photo that shows the story of their connection.

WHEN: Within the last hour before sunset to capture a golden light.

PREP: Does your child admire specific attributes about her grandparent? Is there a special activity they enjoy doing together? Create a photo story that is specific to your child's connection with her grandparents. When photographing older generations, I have found that it's better to not tell them your ideas ahead of time, because they can often worry and back out before you've even shown up. Instead, prep your ideas and come with a clear plan—excited to get their input and take the photo before your visit is over.

FOR P&S USERS: Turn off your flash. Set your camera to Portrait mode so that the background is softened and your child and the grandparent(s) are in focus.

FOR DSLR USERS: Turn off your flash, and set your camera to Aperture Priority mode. Since there are two or more people in this photo, keep your f-stop number a little higher (f/4–f/5.6) to ensure a good focus on everyone's face. You can also try dialing your f-stop down to f/2.0, but make sure you stand farther back and zoom in to get an equally good focus on everyone's face. Depending on how much light is left before sunset, pick the lowest ISO for best color saturation.

COMPOSE: Some grandparents prefer to ignore the camera while you take photos. Other grandparents may have fun suggestions. Before shooting, take a moment to pause and clear any distracting objects in the background.

CAPTURE: Who you focus on will depend on the story of the photo. If everyone is looking at the camera, focus on the grandparent. If everyone is looking away from the camera, you can still focus on the grandparent, or experiment with focusing on the child closest to you.

MY DSLR SETTINGS:
My aperture was *f*/4 to soften the background but keep everyone's face in focus. ISO was 320. My shutter speed was 1/250 sec. (250).

your budding musician

Music is an important part of a child's life. When your child is learning a new tune or practicing an old one, his face shows such intense concentration—he is focused purely on the moment. This is a great age to capture a quiet portrait of your child sitting at the piano. Or, if his instrument is portable, like this violin, try finding a fun, unique background for the portrait. When Nickie Mullen, a former CONFIDENCE Workshop attendee in Alaska, found this field with tires and old, broken equipment, it shouted "all boy" to her and seemed like the perfect location to photograph her son, Kadin. Even if your child's interest in the instrument is fleeting, it's rewarding to capture that passion when it emerges.

WHEN: Late morning or afternoon, when the sun isn't overly harsh. An overcast day is perfect.

PREP: Find a setting that resonates with your child. The old tires and rusting equipment in this shot provided a boy-inspired backdrop. If you have a budding pianist, try clearing space around the piano and even hanging a sheer curtain in front of a bright window in the background for a calm setting.

FOR P&S USERS: Turn off the flash. Set your camera to Portrait Mode for a wider aperture (lower f-stop) and a slightly blurred background. Turn on Continuous Shooting mode in case your child wants to move around.

FOR DSLR USERS: Turn the flash off. Set the camera to Aperture Priority mode, and dial down the f-stop to $f/4$ or lower to blur background details just slightly. Set the ISO to 200 or lower to preserve color saturation. Use Continuous Shooting mode so that you don't miss any shots if your child decides to play a tune.

COMPOSE: A horizontal format works well because it gets enough of the middle ground and background to set the scene; however, if your background is less involved, a vertical frame may work better by putting all of the focus on your child and the instrument. Using the Rule of Thirds (see page 53), Nickie placed her son just off-center, so the tires draw in the viewer's eye. She wanted enough of the background to add interest and depth but not so much that her son looked too small.

CAPTURE: Focus on the eyes. If they are not at the center of the frame, adjust your framing to center them, and lock in your focus; then reframe the original composition and shoot.

AVOIDING MOTION BLUR WHEN INDOORS

If your child plays the piano or drums, you may be limited to shooting indoors. Is he coming out blurry in the photo? If so, your shutter speed is probably too slow. To freeze a child in action, your shutter speed should be 1/125 sec. (125) or faster. If this leaves your photo too dark, try raising your ISO. This brings in more light so you can use a faster shutter speed and freeze those flying fingers!

DSLR SETTINGS: The aperture was set to ƒ/4 to soften the background but still have detail. Shutter speed was 1/400 sec. (400). ISO was low, 200, for best color saturation. Photo by Nickie Mullen

little critters

Becoming an eight- to ten-year-old often brings new opportunities for added responsibility, such as caring for a little pet. Turtles, geckos, fish, and hamsters are popular among families with school-age kids—especially if their children have dog or cat allergies. But I find that many parents are less prone to take photos of their child with small pets. After all, they are so . . . small! Follow this photo recipe to help you document the big bond between your child and her littlest friend.

WHEN: Watch for a time when the house is quiet and siblings are preoccupied for minimal disruptions. This will not only put your child at ease but also ease the racing heartbeat of her small pet.

PREP: Have your child wear a solid-colored shirt so that all the attention is drawn to her hands holding the pet. Plan to take this photo indoors in a bedroom, so if an escape is attempted, the pet is contained. Set up your shot in the brightest room, and have your child sit facing the window light.

FOR P&S USERS: Turn your flash off. Get in close, and treat this like a macro photo by setting your camera to the Tulip icon, a setting for capturing close-up details with extreme blur in the background. You can also try this photo in Portrait mode. Experiment with both to see which shooting mode you like best.

FOR DSLR USERS: Turn your flash off. Set your camera to Aperture Priority mode, and dial your f-stop as low as possible to get maximum blur behind your child and pet. If your child's hands or the pet is moving, or you have low lighting, set your ISO to 400, or even 800, so that you can freeze the moment and avoid motion blur.

COMPOSE: Choose a horizontal format and experiment with the Rule of Thirds (see page 53). Notice how Margo's hands, hamster, and smile are all off-centered, leaving empty space to the left so that the eye is drawn even more to little Julia, the hamster.

CAPTURE: Focus on your child's little critter and shoot away.

A CASE FOR FRAMING TIGHTLY

Experiment with framing tightly—and I mean *really* tightly—so that your child's eyes aren't even in the picture. Notice how by framing out Margo's eyes in the photo shown here, I've drawn attention to the small pet, innocent hands, and her sweet smile. (This photo was taken while filming my Disney show, *Capture Your Story with Me Ra Koh*. Visit www.merakoh.com/littlecritters to watch me demonstrate this photo recipe and more!)

MY DSLR SETTINGS:
My aperture was low, $f/2.8$, to soften Margo in the background behind the pet. My ISO was 500, a little higher because I was shooting indoors and needed more light. The shutter speed was 1/250 sec. (250).

bookworm

Remember when you were a kid and you finished your first novel? The sheer victory of knowing you read all those pages—just like the big books Mom and Dad read—made you walk a little taller, hold your head a little higher. Before you knew it, the magic of books had captured you. The thicker the book, the prouder you felt. We pass an affection for stories on to our kids when they are still babies, and as their passion evolves, it's wonderful to capture moments when they are lost in a faraway land. Lara Gowder, a blog follower in Alabama, accentuated the story of her sweet bookworm by photographing Jack in the library.

WHEN: During a morning or afternoon visit to the library or bookstore, or a calm moment at home. Choose a time when your child is in the mood to curl up with a book.

PREP: Find good light, such as near a large window. If you are in a library or bookstore, find a quiet, out-of-the-way spot or reading nook. At home, choose a comfy chair near a window. Have a book that engrosses your child or a stack of books for younger children.

FOR P&S USERS: Turn off your flash. It will cause harsh shadows and highlights and will also reflect off the glass. Set your camera to Portrait mode for a lower aperture and blurred background.

FOR DSLR USERS: Turn the flash off. Set the camera to Aperture Priority mode, and dial down the f-stop to $f/2.8$ or $f/3.2$ for maximum light and a blurred background. Increase your ISO if the indoor light isn't bright enough.

COMPOSE: In this case, a horizontal format works well, because it shows the long line of bookshelves. If your setting is similar, consider off-centering your child so that your child fills one-third of the frame and the bookshelves fill the other two-thirds. This will allow your eye to follow the long line of books that blur into the background, like Lara did. If there is a window for your child to sit next to, the horizontal format can also provide enough width to capture the child's reflection in the glass (a bonus!). If your background is more chaotic, or not important to the story, consider a vertical format filled mostly by your child and the book. Take a moment to do a quick sweep and make sure there aren't any distracting objects in the background, like stepstools or book carts.

CAPTURE: Focus on your child's face and expression. If his face is not at the center of the frame, adjust to center it, and lock in your focus; then reframe the original composition and shoot.

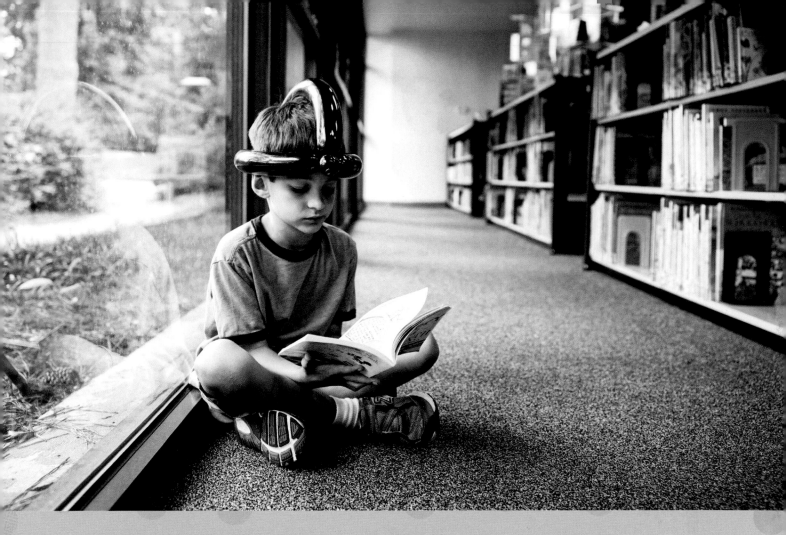

DSLR SETTINGS: The aperture was
f/2.8 to soften both the background
and the foreground leading up to Jack.
The ISO was 400 to get good light.
Shutter speed was 1/160 sec. (160).
Photo by Lara Gowder

objects of affection: part 3

What objects make your house feel like "home" for your kids? The answer might surprise you. When I photographed this family, the mom pulled up with an SUV full of stuff, from an elk's head to skateboards to a big fish off their wall. Little did she know how much her sons loved that big fish! Without hesitation, Jack, the ten-year-old, suggested he hold the fish under his arm and walk through the photo. Invite your preteen to choose an item from home and be an active participant in creating a photo idea.

WHEN: Ask your kids to write down a list of their favorite objects in the house. You can even brainstorm this out loud together. Give them the freedom to choose anything that can fit in the back of the car!

PREP: Find a fun background for the photo that has color and texture. Garage doors, alleyways, and brick buildings are some of my favorites. Also, consider what your child should wear. Does he have an outfit that will clash with the object (like a suit clashes with a fish) to add humor to the overall photo story?

FOR P&S USERS: Turn your flash off, and set your camera to Continuous Shooting mode. If your child is going to move around, as Jack did, select Sports mode, which tells the camera to freeze action. If you are taking a still portrait, select Portrait mode.

FOR DSLR USERS: Turn your flash off, and set your camera to Continuous Shooting mode. If a sibling will also be in the frame, don't go as low in your f-stop. Using an aperture of $f/4.5$ or $f/5.6$ will slightly soften the background but still capture the facial expressions of both children.

COMPOSE: If your child is walking across the frame, go with a horizontal format to accentuate the sense of him "passing through." Experiment with capturing him in the center of the frame or off-centered, so there is more empty space that he is walking toward. If a younger sibling is in the photo, coach him to look at his older brother as he walks across the frame so that the attention is drawn to the big brother and his favorite object.

CAPTURE: Focus on your child's face. If he is walking, have him redo the walk until his face is in clear focus and one of his feet is in midstep. If both feet are flat on the ground, the photo will look like he is standing there posing versus walking through the frame.

MY DSLR SETTINGS: My aperture was *f*/4.5. ISO was 100 for best color saturation. My shutter speed was 1/125 sec. (125).

me and my bffs

The joy of peer relationships often holds center stage at this point in your child's life. Consider ways to capture these precious dynamics. When I asked Pascaline what she wanted for her birthday, she asked if I would do a special BFF photo shoot for her. I was thrilled! Before I could say another word, she started describing the type of photos she wanted. At ten years old, most of her friends don't have phones yet but they love to text. Pascaline envisioned each girl doing something different with her iTouch, whether texting, listening to music, dancing, and so on. This was Pascaline's way of describing her life and what she and her BFFs love doing most.

WHEN: When your son or daughter is going to have a few friends over.

PREP: Before the kids show up, ask your child what type of photo she wants with her BFFs. What are their favorite things to do together, to talk about, to play? Start building ideas for a photo shoot. Look around ahead of time for a fun background—whether garage doors or an alleyway downtown. Make it a fun adventure outing for the kids!

FOR P&S USERS: Turn your flash off. Set your camera to Continuous Shooting mode to make sure you get a frame with everyone looking good. Try putting your camera in Landscape mode to get good focus on everyone in line.

FOR DSLR USERS: Turn your flash off. Set your camera to Continuous Shooting mode to fire a rapid succession of frames. Select Aperture Priority mode, and dial your f-stop down as low as possible to soften the background behind the kids.

COMPOSE: Line up the kids so that they are all on the same plane of focus. They don't have to be in a perfect line, or even doing the same thing, but this will keep them all together and in fairly good focus. Have your child be in the middle. (The subject in the middle is who we usually assume the story is about.)

CAPTURE: Focus on your child's face. You want your child to be sharp, with her BFFs slightly soft-focused—not blurred, just softer in detail.

GROUPS IN FOCUS

The key to using a low aperture like ƒ/2.8 for a group shot is to make sure all subjects are in the same plane of focus—meaning, standing on the same imaginary line; otherwise, only one or two of the faces will be in focus and the others will be blurred. Notice how in the photo shown here, all of the girls' faces fall along the same basic line.

MY DSLR SETTINGS: My aperture was low, ƒ/2.8. ISO was 250 for best color saturation. My shutter speed was 1/320 sec. (320) to freeze the girls in action.

play ball!

It's hard to fathom that only yesterday (or so it seems), you were chasing your toddler around a playground. Now, eight years later, you are sitting in the bleachers, cheering him on as he plays ball. Every stage of your child's life is amazing, filled with wonder, risk, and discovery. When your son throws a pitch that strikes the batter out, your heart and body leap with pride. What better way to share your joy than to capture these unforgettable moments? Wendy Moynihan, a former CONFIDENCE Workshop attendee in Virginia, caught the second just before the third strike was called. Just look at the determination on her son's face!

WHEN: Before the stadium lights come on at an evening game, when the sun is setting (about an hour before it gets too dark to play baseball).

PREP: Every baseball field has unique challenges—from the angle of the sun to visual distractions—so scout around the field ahead of time to find a good spot in relation to the position your child plays.

FOR P&S USERS: Turn off the flash. Select Sports mode or Action mode, if available, to freeze the action. Opt for Continuous Shooting mode, and hold down the shutter release a fraction of a second longer than you think you should to capture every moment of the unfolding action. Be aware that baseball caps cast shadows on faces, so be patient and keep trying.

FOR DSLR USERS: Turn the flash off. Select Manual mode, and dial down the aperture to f/4.5 or lower to blur any background distractions. Set the ISO to between 200 and 400, even when it's sunny, because this will help fill in the shadows on your child's face caused by the baseball cap. Take a few shots, and check if your child's face is bright enough. If you need more light, raise your ISO. You'll need a fast shutter speed of at least 1/500 sec. (500) to freeze the action of a moving ball, swinging bat, or running limbs. Set your camera to Continuous Shooting mode so that you can keep up with the action.

COMPOSE: Horizontal framing will help set the scene, while vertical framing will focus solely on your child. Play around with both to find the composition you like best. Know the rhythm of the game and what specific plays tell the story of your child's role on the team (a triumphantly caught fly ball, a by-the-seat-of-his-pants out at first, and so on). Keep both eyes open so that you can see all the action on the field.

CAPTURE: Focus on your child's eyes, just below the brim of his cap. If that's not at the center of the frame, reframe the image to center the eyes, and lock in your focus; then reframe your composition and fire away.

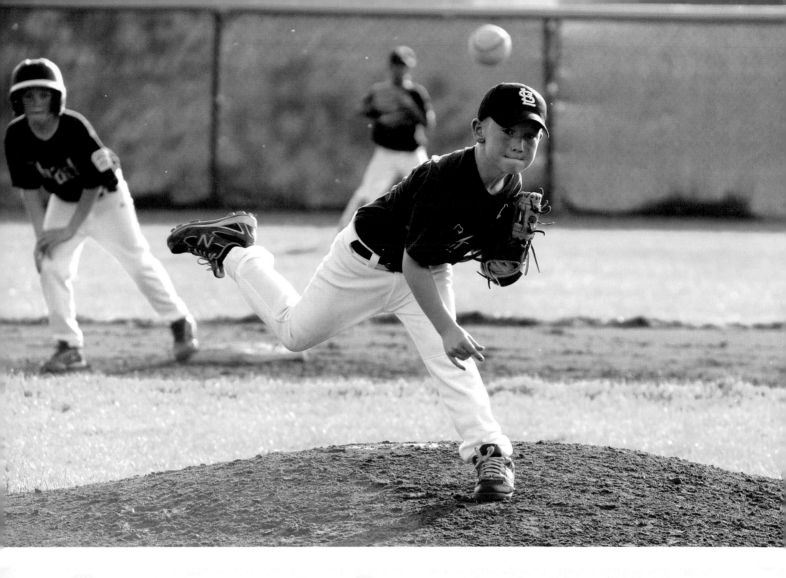

DSLR SETTINGS: The shutter speed was fast, 1/400 sec. (400), to freeze the action, while the aperture was f/5.3, low enough to bring light into the shadows. ISO was 400 to keep the exposure bright on the face. Photo by Wendy Moynihan

tales from underwater

Ever since my kids first started swimming, I have loved watching them move underwater. The weightlessness allows them to move their bodies freely in such a whimsical fashion. One of the best parts of photographing children in this age-group is their willingness to creatively collaborate with you on a photo shoot idea. They may not be dressing up as princesses and superheroes anymore, but why not pull those costumes out one last time and jump in the pool? Your children's creativity will explode at the sheer experience of being dressed in costume while acting out tales underwater!

WHEN: On a sunny, hot day when the kids are up for playing in the pool. You don't need sun to have fun with underwater photos (you can play in a hotel pool any time of year), but bright sunlight adds another dimension to reflections and shadows on the pool's wall and bottom.

PREP: Plan ahead and call your local pool to see if you can make a private reservation. This way, you can avoid having anyone in the background. Also, your kids will be less self-conscious if other people aren't around. In terms of outfits, go beyond swimsuits! Pull out old capes, princess dresses, ties, scarves, even adult-size items from a secondhand store. Remember: the more length to the garment, the more draping and flowing that will result. If your kids are going to dress up in heavy fabric, like an old wedding dress, be sure to have another parent or lifeguard on hand so that one adult is in charge of safety.

FOR P&S USERS: Turn off your flash. Set your camera to Continuous Shooting mode or Rapid Fire. This setting is key because it is so much harder to see movement underwater. It's better to overshoot than miss the shot. If you are having a hard time seeing your LCD display underwater, take a minute to brighten the screen.

FOR DSLR USERS: Turn off your flash. Set your camera to Continuous Shooting mode. This feature is key because of how tough it is to see clear action underwater. Keep in mind that the deeper you go in the water, the more color you lose. You may want to enhance the color in postprocess.

COMPOSE: Take a moment to pause and check the background. Be sure to position your child so that there aren't any ladders or pool logos in the background.

CAPTURE: Focus on your child's face or body and shoot away. Remember, overshoot this photo recipe for best results.

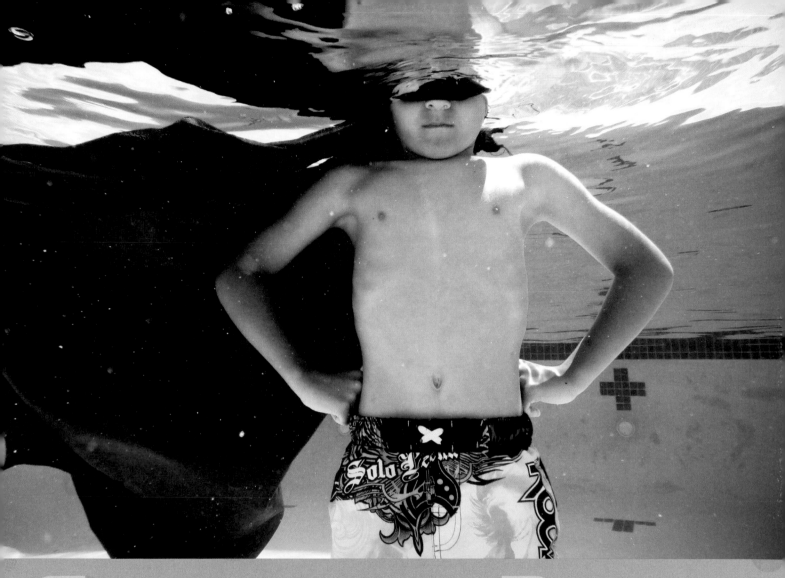

UNDERWATER GEAR

Look for point-and-shoot cameras built for underwater use, an underwater housing unit for your DSLR, or just find a cheap instant underwater camera at your local drugstore. Buy a pair of clear goggles (for you) so that you can see the true color and degree of light on the camera's LCD display. Right before diving in, wash your goggles with a little dish soap to prevent them from fogging up.

MY DSLR SETTINGS: My aperture was *f*/4.5, a little higher than normal since the pool was empty and there were no distractions in the background. The ISO was 125 for best color saturation. My shutter speed was 1/500 sec. (500) to freeze the underwater action.

birthday candles

Every year your child makes a wish and blows out the candles. And every year do you scramble around trying to capture that magical moment? As your child gets older, you can slow things down a little. The mad rush to blow out the candles and dive straight into the cake isn't as intense, so take the time to capture the quiet anticipation—that precious pause full of promise and hope. It's a fleeting breath that's gone all too quickly. Monika McSweeney, a blog follower in California, decided to work with the dark background and convert the image to black and white, heightening the sentiment in this quiet window of childhood.

WHEN: During a birthday celebration, just before your child makes a wish and blows out the candles.

PREP: Have someone else bring out the birthday cake so that you can be in position for the photo. Get in close with your camera, ready to fire. This is a very quick shot. But if you miss it, no one says you can't relight the candles and have your child blow them out again!

FOR P&S USERS: Turn off the flash. Set your camera to Portrait Mode for the lowest aperture to let in the most light. Turn on Continuous Shooting mode so that you can rapid-fire as your child blows out the candles. Experiment with Night mode for capturing moments in dark settings (but make sure the flash isn't on). You can also try setting your camera to black-and-white mode for a more timeless look.

FOR DSLR USERS: Turn the flash off. Set the camera to Aperture Priority mode, and dial down the f-stop to the lowest setting to allow in as much light as possible. Crank up the ISO to 3200 or even higher to get a faster shutter speed. The fast shutter speed is what freezes the flicker of the candle flames. Turn on Continuous Shooting mode so that you don't miss a shot. Consider converting the image to black and white if the high ISO results in visible noise grain or distorted colors.

COMPOSE: A vertical format will fill the frame with your child's face, candles, and cake. Get in close, and have her face slightly off-center from the cake and in the frame.

CAPTURE: If your child is game for relighting the candles a couple of times, experiment with different focus points—like the candles, her mouth blowing, or her eyes. Pick your focus, and if it is not at the center of the frame, adjust your framing to center it and lock in your focus; then reframe the original composition and shoot.

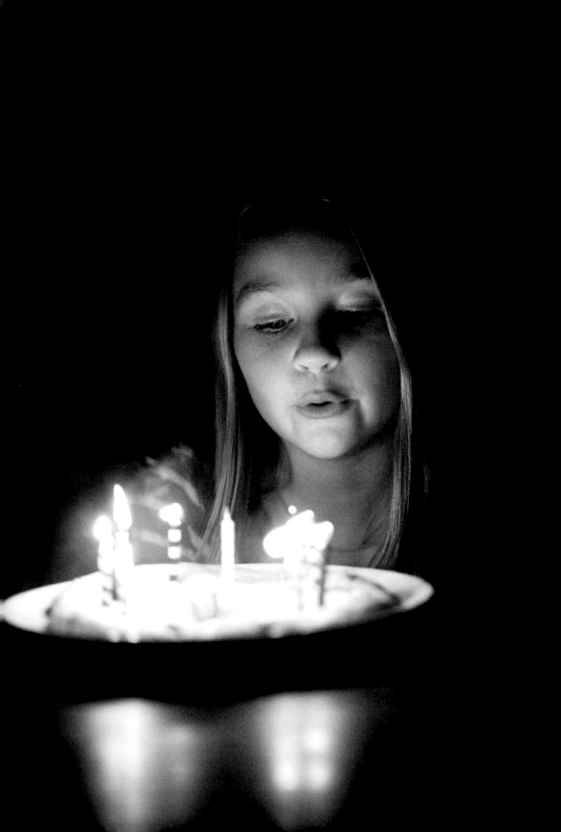

DSLR SETTINGS:
The aperture was dialed all the way down to *f*/1.8 to allow for as much light as possible. Shutter speed was 1/1250 sec. (1250) to freeze the flicker of the flames. The ISO was boosted to 6400 for maximum light. Photo by Monika McSweeney

where do i fit in?

Ten-year-olds have one foot in childhood and the other in a preteen state. Sometimes your child feels grown up, ready to conquer the world. Other times she feels lost, confused, and awkward. To capture this transition, invite your child to collaborate with you on a photo story about moving between these two worlds. I took this photo of Pascaline while on a trip in Thailand. Together, she and I decided to show her at the doorway to our floating bamboo hut, stepping from one space into another. Collaborating with your tween can create not only a great photo but an unforgettable memory of your experience together.

WHEN: When your ten-year-old is in a quiet space, interested in thinking about how she feels.

PREP: A doorway is a wonderful symbol for transitions. But don't feel limited to a doorway; brainstorm with your child about other symbols of passage, like a bridge.

FOR P&S USERS: Turn off your flash. Set your camera to Portrait mode. This will bring focus to your child and a softened background and foreground. If you choose a doorway, as shown here, don't be nervous if your child is dark in the photo. You ultimately want the doorway to be lit and your child to be dark.

FOR DSLR USERS: Turn off your flash. Put your camera in Spot Metering mode; then set your camera to Aperture Priority mode. Lower your f-stop as low as possible for a buttery, blurry background. Take a few test photos. Is your child too dark or too bright? Write down your shutter speed, and determine whether or not you should slow down your shutter speed (for more light) or increase your shutter speed (for less light). Turn your camera to Manual mode, and set your shutter speed accordingly. Experiment with different shutter speeds until you get the right amount of light on your child.

COMPOSE: This photo can be done in either a vertical or a horizontal format. A doorway is often better captured in a vertical frame, which accentuates the shape and lines of the door. But if you have a bigger scene, experiment with a horizontal frame. You want to compose a story that captures the sense of your child feeling alone as she enters this new space.

CAPTURE: If your child's back is turned to the camera, you can either focus on the back of her head or her upper body. If she is not in the center of your image, reframe your image to center her, and lock in your focus; then return to your original composition and shoot away.

MY DSLR SETTINGS: My aperture was low, *f*/2.8, to let in enough light so that Pascaline wasn't a silhouette against the open door. The ISO was 800, again to let in more light. My shutter speed was 1/100 sec. (100).

appendix: tips for photographing your special needs child

uring my second year as a photo expert for the *Nate Berkus Show*, I was asked to visit a family with the film crew for a surprise photo shoot. Nate and his design team were going to redo the family's home office, but they had realized there weren't any family photos to work with for the décor. When we showed up at the family's home, the mom worked to hold back tears as she told me that her eight-year-old son, Tommy, was autistic and had never been able to make eye contact with the camera. She wasn't sure how the family photo shoot would go, especially with a film crew in tow.

(Opposite) Madi was diagnosed after birth with Down syndrome and also had a heart defect that required surgery in her first year of life. One of her only comforts was her mother's hair. Tonya spotted the opportunity and quickly moved over to capture this shot.

DSLR Settings: The aperture was low, *f*/1.4, to blur the background and keep the focus on Madi's eyes. The shutter speed was 1/1250 sec. (1250) with the ISO at 200 because of the bright, open shade. Photo by Tonya Todd, a former attendee and now a certified CONFIDENCE Workshop teacher in Washington State

Special needs seems to be an umbrella term that society has chosen to group all children together—whether their challenges are medical, behavioral, developmental, emotional, or otherwise. Sitting side by side, two special-needs children may have issues that are as different as night and day. In writing this chapter, my desire is not to perpetuate the insensitivity of such a general term but to bring encouragement with photo tips I have learned along the way. Many of these have come from moms who have written to me and shared their experience and expertise. Whether your child has Down syndrome, autism, or learning disabilities, certain universal approaches and tips can help you capture the resilient spirit of your beautiful child.

1. TAKE YOUR TIME. Often, special-needs children take a little more time to get comfortable in front of the camera. Be patient. Autistic children especially need more time to warm up, because they rely heavily on routines.

2. BE AN OBSERVER. Keep your distance until your child is comfortable, deep in thought or play. As his emotions and expressions become more animated, slowly come closer. Avoid posing or directing your child, as he may feel you are intruding. Children with Down syndrome can be receptive to the camera, but they still rely on routine and will be more comfortable if you shadow their activities.

3. SMILE CONSTANTLY. A smiling face is a friendly face. Even if the session isn't going as planned, keep smiling and make sure your child can see it. Positive encouragement will keep everyone relaxed.

4. NATURALLY ENCOURAGE EYE CONTACT. Position yourself so that eye contact is more likely to occur. For example, be at the top of the stairs or wait at the bottom of a slide. And use Continuous Shooting mode so that you don't miss a fleeting glance.

5. PICK A FAMILIAR ENVIRONMENT. Choose a known environment in which your child is comfortable, and allow plenty of time for her to explore and let down her guard.

6. REMEMBER THE THERAPIST. Therapists are a vital part of your child's, and your family's, life. Don't forget to document this special relationship.

In this image, Tommy is with his family—but in a manner that is most comfortable for him. We won't always succeed in capturing a photo with eye contact, but we can still capture the essence of our child's spirit.

MY DSLR SETTINGS: My aperture was *f*/3.5 for a softly blurred background. My ISO was 400, and my shutter speed was 1/125 sec. (125).

With the *Nate Berkus Show* family, I decided to create a game, so our time didn't feel like a "photo shoot." I started by asking for volunteers, which gave Tommy a chance to choose to be involved (rather than being told to do something). Within the game, I had Tommy stand off-center in my composition. Whenever he made his favorite noise, his family cheered behind him. I was aware of not covering my face with the camera so that Tommy could see and feel my smile and, when ready, make eye contact with me. With my camera set up and settings dialed in, I shot away when he made a train sound. Photo captured!

This was the first photo Tommy's mom had ever had of her son looking at the camera—fully present.

MY DSLR SETTINGS: My aperture was *f*/3.5 so that the other members of the family would be in soft focus but still part of the overall story. My ISO was 200 for best color saturation. Shutter speed was 1/125 sec. (125).

A family portrait should represent a family's truest state. I love how Tommy is peacefully looking away from the camera here because this is "their Tommy." The photo represents the beautiful, diverse dynamics between Mom and all of her kids.

MY DSLR SETTINGS: Just as for the photo opposite, my aperture was f/3.5, the ISO was 400, and the shutter speed was 1/125 sec. (125). Once I get my settings figured out, I try to avoid changing them so I can stay engaged with the kids.

What I didn't expect was Tommy's mother's intense, emotional reaction to the photo. I've spent years allowing space for children to *not* look at the camera, but Tommy's mom graciously reminded me of how a parent with an autistic child often dreams of having eye contact, that single connection, when she knows her child sees her and in turn the child knows he is seen by the parent. This was the first photo of Tommy that his family ever had where he was looking at the camera.

Months later, the *Nate Berkus Show* brought us all back to see how things were going. I started to cry when Tommy's dad said something had shifted inside of Tommy after that day. He now enjoys the camera. He feels like it's a game that he gets to choose to play. They have caught several photos of him looking at the camera since our time together.

What works for one special-needs child may not work for another. But the pursuit of finding a way to connect, to give your child voice, is worth all the time it may take. It holds the kind of reward that gives your heart wings. As you know so well, your child sees and experiences the world on a different plane than everyone who surrounds him. The world needs to hear his story, see through his eyes, experience his reality—because every time your child lets you in, opens a door to connect, hope is multiplied.

Aidan, Chase, and Brady are triplets. Chase was born with cerebral palsy and spends most of his awake time in a wheelchair, unable to sit up on his own. The beauty of this family's story is how these brothers lean on each other, giving comfort, joy, and love to one another. While I was taking a photo of them straight-on, Brian (my husband) captured a different point of view that accentuates Chase's joy even more. Photo by Brian Tausend

Daniel was diagnosed with neurofibromatosis, a progressive genetic disorder that includes an inoperable brain tumor, epilepsy, vision deficits, and fine and gross motor delays . . . to name just a few. Yet according to his mom, someone forgot to inform Daniel of his disorder because he faces everything in life with a huge, genuine smile. This photo captures that terrific smile. Photo by Jess Robertson, a former attendee and now a certified CONFIDENCE Workshop teacher in California.

Taylor had a near SIDS event at two months old, causing an anoxic brain injury that led to spastic quadriplegia and cortical visual impairment. Now in sixth grade, he has a contagious laugh and drives his power chair with his head. He thought it would be funny to chase Summie, the photographer, as she tried to capture him, and the session became a game filled with giggles! Photo by Summie Roach, a former attendee and now a certified CONFIDENCE Workshop teacher in Texas

Every child, no matter what the diagnosis, gives us a gift when they allow us into their world. An autistic child may struggle with looking at the camera, whereas a child with Down syndrome may be more intrigued with the camera. Being sensitive to the individual child and his or her particular needs is where we must start. Photo by Michelle Slape, a former CONFIDENCE Workshop attendee in California

Note: Special thanks to Michelle Slape, Susan Burchard, Allison Gallagher, Jess Robertson, Summie Roach, and all of the moms and photographers who shared their beautiful wisdom in this section.

Photo by Brian Tausend

last words:
THE POWER OF PHOTOGRAPHY

A wise woman once told me that the most important gift you can give your children is to help them love who they are. If they do, they will develop a deep confidence in their strengths, acceptance of their weaknesses, and appreciation of what makes them unique. Every subsequent choice will be made from that solid foundation. You will have succeeded as a parent. Photography has been a vehicle for me to do this with my children.

Through the camera, I have been given the opportunity to slow down and watch Pascaline and Blaze's unending growth. I have learned to notice the small details that define their present stage of childhood as well as discover new

mannerisms that hint at their next developmental stage. The camera has also been a vehicle for building trust with my children. We have learned together how to strike a balance that works for us—sometimes I chronicle their story and sometimes I leave the camera behind to be present in a different way. Through all of these explorations as a parent and artist, my heart's mission has been to give my children voice.

I see a dynamic happening among parents with their picture-taking. We initially set out to chronicle our child's life, yet somehow things tend to shift. Equipped with faster cameras and bigger cards, we start taking thousands of photos. We unknowingly burn out our kids, and they start to feel invisible. Some of our children lose their voices in all our shooting.

But we can change this. We can document their lives with intention. Instead of trying to shoot everything, we can choose to tell a single story. Instead of taking pictures until we get "the shot," we stop when the timer goes off—whether we got it or not. Instead of being the only one who takes pictures, we can hand the camera over as our children get older. We can ask for their creative input and, in turn, help them develop their voice. And most of all, we can be willing to miss good shots to get great shots.

Photography is a wonderful way to capture your child's life. But the act of photography goes much deeper than picture-taking. It is also a powerful tool for healing. Countless times I've witnessed how a single moment captured can bring healing to a child's life. I've watched a young girl's face light up when she saw how beautiful her laugh is—even with her front teeth missing. I've watched a boy walk a little taller when his idea was used for the family holiday photo.

Maybe you are reading this and feel your heart resonate with what I'm saying. Your passion for photography started with your child, but, like me, you feel the passion growing into something more. I encourage you to follow the invitation your creative spirit is extending. If you need a daily dose of encouragement, visit my website at merakoh.com for more photo recipes, video tutorials, and a supportive community that empowers each of us to create and capture! I also invite you to share your photo recipe results on my Facebook page. Ever since *Your Baby in Pictures* was released, it has been wonderful to have readers post their own interpretations of the photo recipes and see the uniqueness in every eye.

When you pick up your camera to capture your child's life, you are stepping into a creative space that has limitless possibility. You are not just the family documenter. You are also a healer. What wounds of insecurity can you heal today? What taunting voices of not feeling pretty enough, cute enough can you quiet in your nine-year-old's heart? What innocent bond between a four-year-old and his teddy bear can you preserve with a single photo? These are the powerful moments that ask to be captured.

Some of your photos may not turn out, but many will. In all the trying, learning, and pushing of your own creative boundaries, take a moment to pause—to look up from your focus—and see how you are not only capturing treasured memories but healing the world one child at a time, starting with your own.

Much, much love,
Me Ra

Me Ra Koh

Psalm 126

index